THE RAILWAY PAINTINGS OF
DON BRECKON

THE RAILWAY PAINTINGS OF
DON BRECKON

DAVID & CHARLES
Newton Abbot London North Pomfret (Vt)

To Meg

First published in 1982
New, compressed edition 1987

Breckon, Don
 The railway paintings of Don Breckon.
 New, compressed ed.
 1. Breckon, Don
 2. Railroads in art
 I. Title
 759.2 ND497.B68/
 ISBN 0–7153–9078–3

Printed in Hong Kong
for David & Charles Publishers plc
Brunel House Newton Abbot Devon

Published in the United States of America
by David & Charles Inc
North Pomfret Vermont 05053 USA

CONTENTS

ACKNOWLEDGEMENTS

Thanks are due to the following, who have lent paintings for reproduction in the book:

Mr & Mrs P. A. J. Abbott	'Sunday Working'
The Barbican Gallery, Plymouth	'Lostwithiel Station', 'Southern Crossing' and 'Eastern Branch'
Mr Gidley Evans	'Night Stop'
Mrs S. M. Hodges	'Manor at Brownqueen'
Mr & Mrs I. Kitt	'Fowey Valley'
Mr & Mrs J. McNulty	'Earl of Mount Edgcumbe'
Mr C. G. Portass	'Tunnel'
Mr L. Rollason	'Working at the Shed'
Mr & Mrs Patrick Russell	'North British'
Mr R. Sabatini	'British India Line' and 'Along the Tamar'
Mr David St John Thomas	'Back from Town'
Mr Owen Smith	'Traction'
Mr & Mrs J. D. Stitson	'A Star in Winter'
Surg Cdr D. Waddington RN	'Evening Star on Shed'
Mr J. Waghorn	'Moorswater Shed' and 'The Rifle Brigade'
Mr V. Watson	'King's Cross'
Mr & Mrs D. Wheeleker	'Jinty at the Crossing'

'Morning Delivery', 'Wayside Halt' and 'Midland Local' are in the artist's collection and 'Racing the Train' is in a private collection.

Acknowledgement is also due to:

Solomon & Whitehead (Guild Prints) Ltd, who have allowed us to reproduce the original paintings 'Sunday Working', 'Racing the Train', 'Manor at Brownqueen' and 'Jinty at the Crossing'. The pictures are available in print form, published by Solomon & Whitehead (Guild Prints) Ltd, who own the copyright.

The Barbican Gallery, Plymouth, who hold the copyright of, and have published as Collector's Edition prints, 'Wayside Halt', 'Midland Local', 'Southern Crossing' and 'Eastern Branch'.

Bill Hodges of the Barbican Gallery, Plymouth, who made this book possible by gathering together the paintings for reproduction.

PUBLISHER'S PREFACE

Don Breckon is a very unusual man. I admire him for the totally honest way in which he draws satisfaction from what he does, and for the pleasure he gives to others. Then, though his work has the technical accuracy to please the most fastidious nuts-and-bolts man, he is also a true artist; not just a painter of documentary pictures. His work has imagination and leads the viewer to develop his own fantasies. I know because I have lived with one of his paintings for many years, and while it is always satisfying just to look at what is there, it also has the gift of stirring my thoughts one way today and another tomorrow. It lives.

It gives me much pleasure to publish this collection of his paintings and other work. Many people will quickly establish a favourite, but it is a collection that deserves to be lived with in its totality, capturing as it does the steam railway in many of its varied moods.

And what is it that is so special about the steam locomotive? Many people have their own idea, but the range of possibilities is enormous. Even the locomotives at the end of the steam era were the descendants of the first machines that carried man faster than an animal and that largely brought about the order of the world we know today. The historical continuity and complexity of locomotive design has of course attracted a large literature, but you do not need to be a convinced railway enthusiast to have your own favourites and to voice opinions as to whether the livery, the positioning of nameplates, the rebuilding or modification of a locomotive are satisfactory. And who among us has not been awestruck by the sheer size of the beast and of its stocks of coal and water for devouring at speed, or, if lucky enough to receive an invitation to the footplate, has not felt his stature increase? Every glance at the controls is a reminder that maximum power does not come at the turn of a handle; steam locomotives need to be understood, sometimes coaxed. You could often tell the character of the driver as well as that of his locomotive on hearing a train struggling up a gradient in adverse weather in the days when steam was the common workhorse, not just 'preserved'.

This collection, too, has much to do with characters. Whatever your interest in railways, it will enhance it, help recall the colourful days of yesterday and perhaps give extra meaning to your next visit to a steam centre.

David St John Thomas
Brunel House
Newton Abbot

NOTE TO THE 1987 EDITION

Not merely did this book sell quicker than we expected and attract more favourable comment, but since I have had the pleasure of publishing *Don Breckon's Great Western Railway* and he is now working on *Don Breckon's Country Connections*. Published in their original lavish format, the titles are inevitably expensive (though I cannot recall a single complaint about value). This slightly compressed format (the margins have of course been trimmed more than the pictures and text) will make the book available for an even wider audience of those who love railways and enjoy Don Breckon's rare combination of accuracy and true art.

David St John Thomas

INTRODUCTION

Roger Malone

Like many people my introduction to Don Breckon took place when I strolled into the Barbican Gallery on Plymouth's picturesque waterfront. Here, amidst the inevitable seascapes and rolling Dartmoor scenes, were a couple of steam engines. They were in such a state of high animation—accelerating with smoke billowing from their chimneys—that I was instantly captivated. This discovery was all the more pleasantly incongruous because the latter-day Barbican was not a place normally associated with the world of railways. Yet here, amidst the trawlers, fishermen and numerous pleasure craft, were to be found the beginnings of a steady stream of steamscapes.

Being a journalist with an infinite preference for writing about creative people rather than general reporting, I suggested to the gallery proprietor, Bill Hodges, that a feature on Don Breckon would make an absorbing read. My interest, I confess, went deeper than just 'getting a good story'. For a railway enthusiast such as myself, meeting the man behind the trains would be in itself a pleasure, while the chance to write about him and his work brought particular delight. Warned that Don was a reserved man not over-eager to meet the 'men from the media', I drove towards his home in Lostwithiel anxious yet equally delighted that he had agreed to be interviewed. Flanking me on the left as I crossed the Tamar into Cornwall was Brunel's famous railway bridge and ahead lay a whole morning of train chatter . . .

Lostwithiel appeared as a pleasant bowl of a town surrounded by hills, and on the outskirts was the artist's large rambling cottage. Writing a feature has certain analogies with creating a painting. First impressions are important in capturing the tone and a person's chosen surroundings often provide as many clues to his character and interests

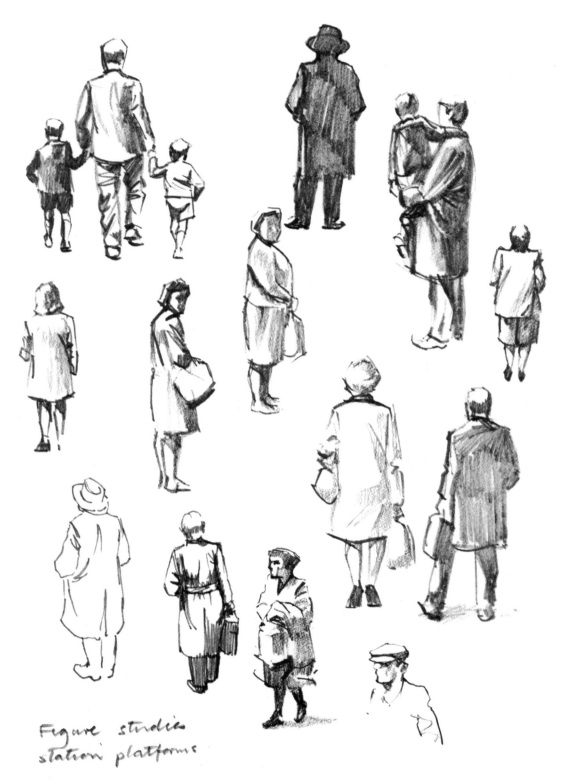

Figure studies
station platforms

as the spoken word. As soon as I stepped into the front room the railway influence was obvious. Mounted above the fireplace was the beautiful Castle-class locomotive nameplate '*Beaufort*', and at the other end of the room was a large model of an LMS 2–6–4 tank. Scattered around were freshly completed paintings needing final touches, or commissions awaiting delivery to their owners.

Don spoke in a quiet voice about railways in general and his paintings in particular, while his wife Meg provided an endless supply of coffee. His accent still bore faint traces of a Northamptonshire childhood, and a dry humour soon emerged. Deft anecdotes of his artistic career were delivered and forged a fascinating picture of the painter.

Since then I have had the pleasure not only of seeing many more of his railway paintings but also of becoming a friend of Don and his family. When he asked me to write an introduction to this, his first book of train paintings, I was delighted because it gave me the opportunity to express the appeal that I and numerous other admirers have found in his work. Having talked on many occasions to Don about his life, his paintings and his love of steam locomotives, I have tried to show not just his evolution from student to successful artist but also the way a complete involvement in his subject transforms a two-dimensional canvas into a three-dimensional reality with a life and movement of its own.

Don Breckon was born in 1935 in Corby, an outpost of industry amidst the rolling Northamptonshire hills. Here, during the height of the steel town's prosperity, the blaze of the blast furnaces burnt the night sky orange. Don remembers how these holocaustic colours could be seen for 15 miles as the cauldron fires reflected in the drifting banks of cloud. Large excavations radiated out like raw fingers probing the local landscape and plundering acres to feed the Works' insatiable appetite for iron ore. Shifts of men worked around the clock while the smell of sulphur clung to the prevailing wind as a constant reminder that the community's growing wealth was founded on the production of steel.

Don's father was a controller in the ore-crushing plant and the family lived in a semi-detached house owned by the steel company. The eldest of three, his earliest recollections were understandably of the Works, whose intimidating proportions wholly

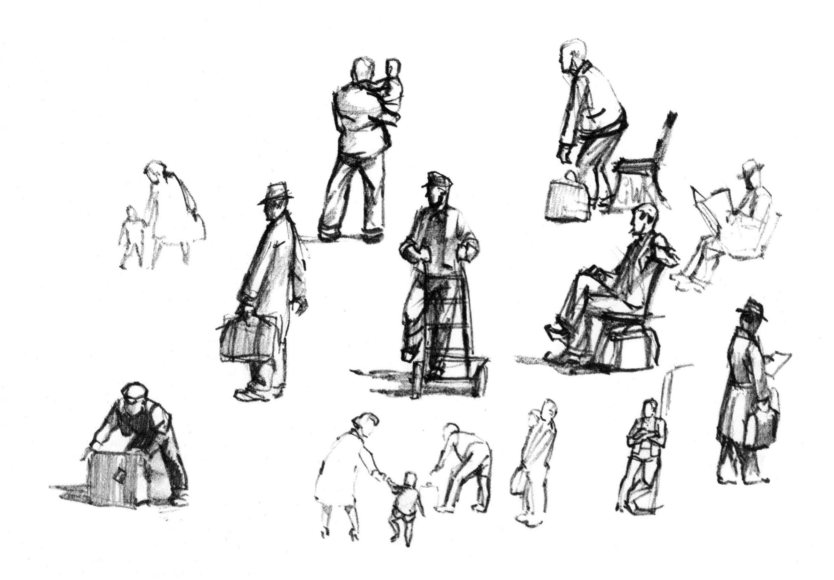

dominated the town. The huge blast-furnaces presented both a frightening and engaging aspect to the young Breckon.

Corby had by now earned the nickname 'Little Scotland'. But while this might suggest that the local community was blissfully unaware of Hadrian's Wall, a closer look revealed that it was all too aware that it had been 'breached'. What had been, until the 1930s, a country village peopled with indigenous accents now housed a rapidly growing community of Celts imported from north of the border to work for the steel company. Corby, it was obvious, would never be quite the same again.

For the men it meant welcome employment in hard times, while for the children it meant ravaged landscapes of lunar proportions where they could act out all the adventures of their heroes. While the Saturday-night pubs were filled with Glaswegian accents and the one-time village adopted characteristics of a frontier town, the children fed their fantasies with westerns and Flash Gordon at the Saturday-morning cinema.

Behind the Breckon home in West Glebe Road, a large opencast iron-ore working known as 'The Wessy' became the impromptu arena where celluloid shoot-outs were re-enacted, with sticks for six-guns. There were no candidates for Boot Hill but

C Gull

Jan 77

Doc Holliday could have run a lucrative practice bathing grazed knees and elbows after skirmishes with rival gangs. Ravines and gulleys—vast adventure playgrounds—stretched for miles, gouged like open brown wounds in the once meadow-fresh Northamptonshire slopes. Wastelands abounded where barren spoils gave a begrudged birth to plants with Latin names more commonly called weeds.

While a child, carefree and almost oblivious of the war that was raging beyond the comparative peace of Corby, Don Breckon was subconsciously absorbing the mood and atmosphere of the industrial town that would one day re-emerge as strong angular shapes in his early impressionistic paintings. A kaleidoscope of colour from those embryonic years was to distil into a deep appreciation of industrial landscapes long before he developed an even stronger commitment to the world of steam engines.

As a pupil at the local school, where reading, writing and arithmetic were taught under the smoky shadow of the all-powerful Works, Don's awareness of steel and steam grew almost simultaneously. No walk home, with satchel swinging, was complete without straddling the parapet of a nearby bridge to watch the 'pug' saddle tanks shuffle busily along the buckled industrial tracks with 'cauldron wagons' of molten metal. The possible *pièce-de-résistance* of this performance was the cacophony of clashing buffers which set up when the locomotive jarred and jerked too vigorously, causing a spectacular and applaudable display of spilt white-hot metal much appreciated by the youthful audience.

The war years passed. In Corby air-raid shelters became redundant and an enigmatically named Occupation Road fortunately never lived up to its daunting title. The town was never deliberately attacked, although the Lúftwaffe occasionally dumped their last bombs in the vicinity before heading home. In peace as in war the community continued to revolve around the local industry. Shift-workers still cycled in and out of the Works' gates with their haversacks and thermos flasks, while the 'pug' tanks' pert whistles pierced the night air as they chattered noisily up and down the sidings. It seemed as though Corby never truly went to sleep . . .

The main line to Nottingham ran nearby, but it was not until Don passed the eleven-plus and began to travel the 8 miles a day to Kettering Grammar School that both he and his school-friends developed into ardent train-spotters. Kettering was a whole new world. It offered a glittering counterpoint to the limited confines of Corby and on Saturdays people flocked there because it boasted two cinemas and a Woolworths.

It was now 1947. The Breckon family had moved to Wheatley Avenue on the outskirts of Corby, and Don, although delighted to have escaped the local secondary modern, was not finding life academically easy at the grammar school. But even if the Kettering boys had little regard for the Corby boys and the maths and Latin masters left Don in no doubt as to the unlikelihood of his becoming a scientist or scholar, there were consolations.

There were weekly art classes which arrested any rumours about his apparent lack of ability. At an early age his drawings had shown promise and he was now getting the guidance needed to expand an obvious, but until now overlooked, natural talent. Apart from the saving grace of the art class, there was the lunch-time dash down the hill to Kettering station. Here the train-spotters gazed with awe on the antithesis of Corby 'pugs' rocking giddily along the twisted toy-town track of the Works' sidings. Kettering was on the St Pancras–Scotland main line and no lunch-time was complete without the sightings of a couple of LMS Jubilee locomotives. Two midday expresses were usually in the capable charge of this elegant class and made a fine spectacle accelerating through the station. The school-boys' most difficult dilemma arose if an express happened to be late: the unbearable choice was between waiting—risking detention, which meant no lunch-break the following day—and cutting their losses by departing dejected but punctually back up the hill for afternoon lessons.

By now Don was armed with an Ian Allan train-spotters' book, which opened up a dazzling vista of locomotive classes roaming the railway network, hauling mighty expresses from one end of the country to the other. As the snout of the snorting Jubilees came into sight, Don's eye would immediately focus on the nameplate above the splasher to see if it was a new 'cop'. A bigger punishment than detention was being told by gleeful colleagues that

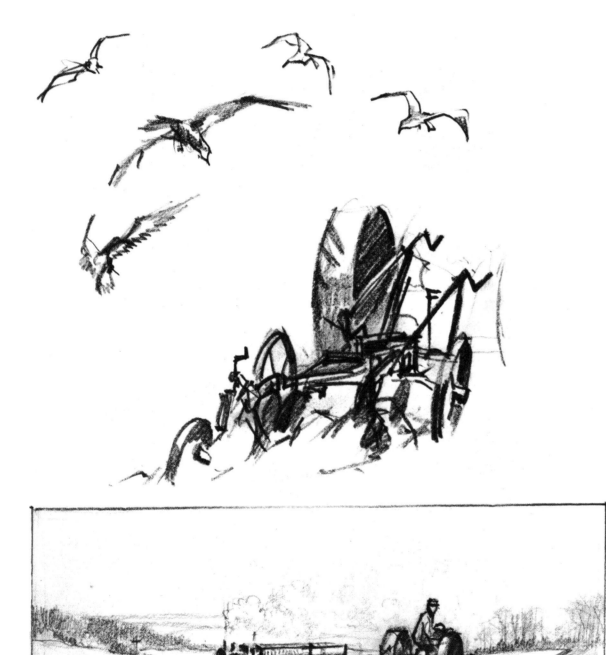

an as yet unspotted member of the class had stormed through Kettering while the erring pupil was sitting out valuable 'copping' time in the punishment class.

Trains ran comparatively infrequently over the Nottingham line which skirted Corby. To ensure maximum use of free time, the local train-spotters perfected the fine art of interrupting a football or cricket match at pre-ordained intervals. This allowed a quick dash to the lineside to watch a specific train before returning to the game. One scheduled working that could on no account be missed was the 6.45 pm 'plum and spilt milk express', whose red and cream coaches were usually headed by one of the new experimental light-green-liveried Jubilees. The only other interruption tolerated on the pitch was the mad evening scramble home for the latest exciting instalment of the adventures of the radio James Bond of his day—Dick Barton.

To the north of Kettering lay Glendon Junction, where the main line to Scotland split from the secondary route to Nottingham. Once discovered by the Corby train-spotters—who had now gained increased mobility by acquiring cycles—this railway utopia became a regular haunt. It was here, on summer Saturdays, that they watched a never-ending procession of north- and south-bound expresses of the new post-nationalisation era. Lazy, sultry afternoons lolling in the long grass, consuming unhealthy quantities of sandwiches and bottles of pop. Hours droned by, punctuated only by the 'ting-ting' of the signal-box bell and the buzz of pollen-laden bees. Then eager eyes would scan the up and down roads. Watching. Waiting. A signal arm would clatter in the gantry disturbing the concentration of a hawk hovering above the embankment. The distant beat of a north-bound train making the heart pound with anticipation. Polished rails starting to sing. Volcanic smoke as the mighty express thunders by like a thoroughbred stallion. Sun glinting off the boiler. The roar and majesty of this superlative vision of power. Then the voluminous smoke drifting, spiralling and disappearing like a dream. Rails singing themselves back to slumber. The signal reset. Anticlimax after the excitement. The hawk regains its composure and the train-spotters settle back in the sunshine to wait for the next 'ting-ting' . . .

Then came the crimson pacifics of the Euston line, which meant cycle trips of 25 miles to Blisworth, the other side of Northampton. Here the magnificent Duchesses and Royal Scots ruled the rails, hauling their string of coaches through the station with such speed that eddies of soot and spent platform tickets whirled in their wake. These steam celebrities were interspersed with anonymous freight traffic, which never commanded the same respect from the youthful observers. These black unsung heroes of various shapes and sizes plodded balefully about their business, doomed forever to be the drudges and never the aristocrats of the railway scene.

But as the cycling increased, so the train-spotting decreased. The lure of the railway diminished and Don began sketching rustic parish churches, and touring the Welland Valley with a notebook and pencil.

In 1954, when he was nearly nineteen, Don did his national service at RAF Patrington near Hull and found that drawing cartoons 'took the edge off square bashing'. Two years later he entered the Bath Academy of Art to train as an art teacher. The college was in the stately home of Corsham Court, an elegant property in the picturesque Wiltshire village of Corsham. The golden natural stone of the local cottages and the nearby architectural splendour of Bath captivated him. Its mellow refinement was the antithesis of industrial Corby. But while Don enjoyed his new environment, he found less affinity with the artistic teachings of the Academy. With retrospective amusement he recalls how still-life subjects were either 'grey frying pans or elderly nudes'. His eye for accuracy was overlooked in the more lofty pursuit of abstract impressionism.

While Don's natural tendency was to recreate his subject as exactly as possible, his tutors preached a different doctrine. They believed that photography had replaced painting as the topographical medium, thus freeing the artist to be more introspective and analytical about what he saw. Feeling torn between his instincts and his mentors, Don became enmeshed in a dilemma that caused conflicts and inner confusion for several years after he left the Academy. His own convictions had been eroded and yet he found it hard to accept the alternatives. The resultant work was a compromise between two camps—a divided allegiance which

Tractor & train

weakened any conviction about either of the opposing poles. One tutor's suggestion for loosening up the tension in Don's drawing was 'a large stiff drink'. The message was clear: the work had to flow, to shrug off the constraints of the visual chronicler and allow a more fluid interpretative style to take over.

There was, however, one moment of glory when the principal reviewed an exhibition of the students' holiday work. Pausing to appraise a Breckon abstract impression entitled 'Corby Steelworks', he announced to a hushed gathering: 'This artist has become airborne!' Don heaved an inward sigh of relief. Somehow he had struck all the rarified chords of impressionism in one harmonious canvas.

The Academy, like many art colleges, felt it essential to break up all preconceived ideas and encourage a vaulting creativity that scaled contemporary barriers. If its esoteric quest left the ordinary public behind, then it was for the public to catch up and not for the creator to stagnate. Scientists were constantly exploring and so must the artist. Don could never totally ally himself to this philosophy, but the college had made its mark and opened up a freer acceptance of new ideas.

When he began teaching art at Kempston Secondary Modern School near Bedford in 1958, his spare time was occupied by painting abstracts, with linear perspectives being one of his favourite themes. It was while visiting an exhibition of students' work at a college in Bedford that Don was intrigued to see a painting of Bedford railway station. At that time he little realised this was the work of a student who was later to become his wife. A few months later Meg Downe—that same student—arrived at Don's school as the new P.E. teacher! When he moved to Reading in 1962 Meg moved as well, first to a secondary school and then as a lecturer at Bulmershe College of Education. The following year they were married.

Meg always took a keen interest in Don's paintings and encouraged him to develop his own style. By now he had sold his first canvas, when it was displayed at the Kettering Art Society exhibition. It was an impression of Corby New Town centre at night. He got five guineas and was 'walking on air!' At the same exhibition several years later he won the Salisbury Prize with 'Terminus'. The railway influence was creeping back . . .

He was now teaching at Maiden Erlegh School, but was beginning to feel vaguely restless in his academic role. 'Cityscapes', as well as industrial scenes, were still being produced in his spare time, and a steady outlet for the finished works had been found at a local gallery. His first one-man exhibition took place—in a Reading furniture store. It is the only time he has ever made a personal appearance alongside his paintings. A shyness about public gatherings convinced Don that once was enough. At subsequent and increasingly selective showings he has chosen to stay at home, and let his paintings do the talking.

His work had started to go through a phase of gradual change. The challenge was going out of teaching and he went part-time, doing three days a week, to extend his painting. Meg's salary as a lecturer made this practical and she actively encouraged him to take this important step in developing his work. Already he was starting to move away from abstract ideas and re-explore more accessible images.

Frequent visits, armed with sketch-book and camera, to disused branch lines and derelict stations began to provide a new set of themes. Here, in the wind-blown quietness, ghosts of the past lived on. Dandelions and daisies populated the platforms. Roses clung desperately to rusted railings and clusters of bramble-berries shone a polished mauve in the evening sun. The buildings were tarnished but nothing had changed. For Don it was like stepping back in time. If you listened closely you could still hear the clatter of milk churns, the clank of couplings, and the wheeze and shuffle of the local train. The atmosphere of the decaying stations, with their blind, boarded windows, inspired a million railway scenarios. Imagination could fly. It was as if someone had left in a hurry without tidying up. Tattered shreds of timetable flapped in the waiting room while outside the sad tale continued: a wheel barrow with no wheels, buckled buckets, a broken bicycle . . .

It was not just the architecture of the station structures and the abandoned appendages that fascinated Don. It was the unreal solitude that had consumed what had once been a bustling focal point. There was a presence in these places that refused to die. They had seen too many seasons, watched too many changes to remain silent. The

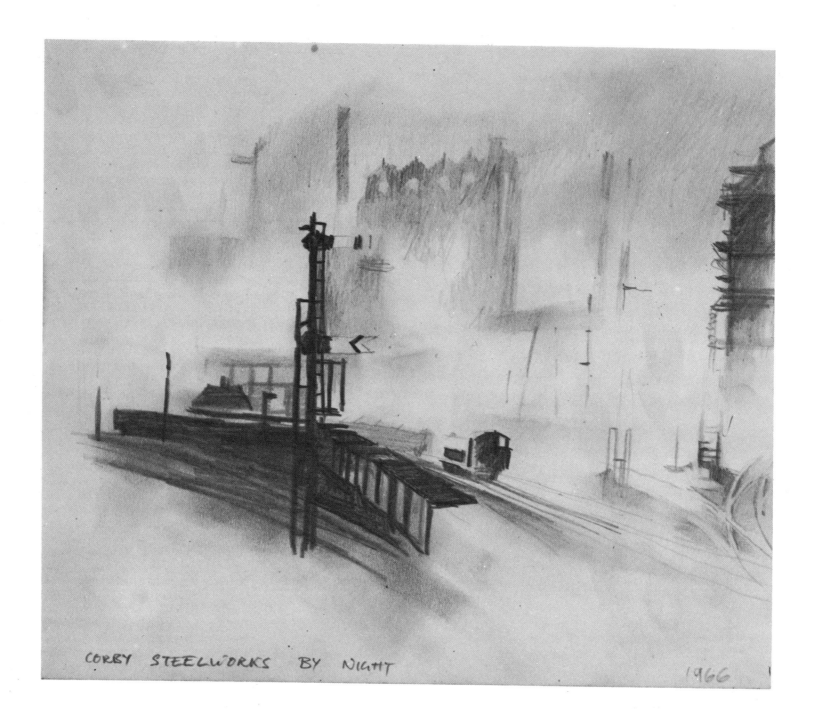

CORBY STEELWORKS BY NIGHT 1966

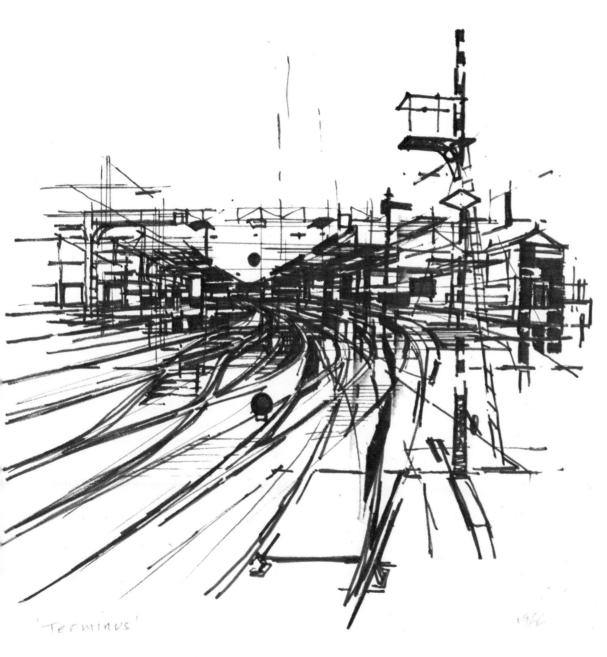

'Terminus' 1966

only finality to the whisperings was demolition. The advancement of nature merely entombed buildings and bestowed upon them an almost metaphysical power. It did nothing to stain their pride or terminate their tortured souls. On the contrary it made brick-and-mortar martyrs of them.

They had become last bastions of an era gone. Redundant images whose stories shrieked in the silence like the ghosts in some deep, dark dream. The mind could spin back to the first excavations. The local excitement at the top-hatted opening ceremony. Bunting. Speeches. Celebrations. The expanding railways bringing better comunications and new prosperity to the community. A way of life. Halcyon days. Long hay-sweet summers where the rural pace was attuned to the natural order. The morning goods, afternoon mixed, market specials and passenger trains that clung to the contours of meandering valleys. Quiet cuttings. Wayside crossings. Country towns, hamlets, halts, homesteads, farmsteads click-clack click-clacking by. The reassuring familiars of all those who travelled 'the branch'.

As twilight falls the telling walls invite the intruder closer to their ivy-clad privacy. Long before the end, the treason of change hung in the air. What was would not always be. The rural railway had slipped into decline and the country station, with its staid Victorian elegance, was now labelled an unprofitable folly. Pride died as the death knell tolled nearer. Stations grew drab with neglect and indifference as one by one they closed, to appease an evolving policy of modernity and streamlined efficiency. The message was growing louder and clearer all the time: the railway system was changing and casualties would be heavy. Trains were run infrequently and consequently often ran empty. The golden years of the country branch were over.

Now dusk consumes the station in a silent shroud. Darkness grows out of the shadows where once oil-lamps showed the way. A barn owl swoops low over the platform before quartering the nearby fields on its first mouse patrol of the evening. The last train has long gone, its tail-lamp extinguished for ever by the enveloping night. The track bed has now inherited a new breed of commuter—the hiker and historian beating back the brambles to explore

afresh this anachronistic corridor of countryside.

The walls have had their say. Their memories are embalmed in moss. The spectral shapes of ghostly trains struggle in vain to be tangible once more. During his visits Don crams his sketch-book with these evocations of the past. He leaves the stations to their midnight staff of grunting hedgehogs and wet-nosed foxes. His imagination has peeped behind the curtain of decay and in some future painting he will restore the scenes to their former glory.

Although visiting disused branch lines brought out a deep artistic respect for decaying architecture, it failed to impart any sense of the speed of the change overtaking the railways. Stations quickly acquired the dignified dereliction of ruined castles, a ruse that suggested their present state had been constant for the past century.

Front of Locomotive 5043 Barry Aug 7.65. "Earl of Mount Edgcumbe"
Castle class Scrapyard

It was once on his way home to Corby that Don became suddenly aware that the railways he remembered from his childhood were changing— and rapidly. At a locomotive scrap-yard on the outskirts of Kettering he saw the bright flame of the acetylene cutter sear into the metal like a sword. Segments fell away like bits of broken toys. It was the execution of steam. An ignoble end to the coal-fired giants of the pre-diesel age. Here, in the drab scrap-yard confines, was the unequivocal end of the road. The locomotives' worth was measured in terms not of past heroics on gruelling gradients but of the going rate per ton of scrap metal. The juxtaposed remains formed an abstract image in their own right, and after his visit Don produced a series of drawings and paintings of all that remained of the trains he knew.

While the rapid annihilation of steam engines near Kettering came as a savage jolt, a visit to the comparatively becalmed locomotive graveyard at Barry in South Wales offered something of the sombre tranquillity found in a cemetery. Sidings were packed with hundreds of large grime- and rust-clad engines, resting buffer to buffer like beached whales. Don moved amongst the redundant hulks sketching a record of the scene. Castles and Kings, Manors and Halls from the now totally dieselised Western Region still possessed their elegant Swindon line, but ravages of time and the removal of copper and brass embellishments dulled their once highly polished pedigree. It was 1966 and the Southern still had a year to go before it totally withdrew steam, but the scrap-yard was already swelling its collection of Bulleid pacifics— the mighty Merchant Navy class and the lighter West Countries and Battle of Britains. Don also found a smattering of LMS locomotives—including Jubilee-class *Galatea*, a familiar from his lunch-time train-spotting days at Kettering station.

All the engines had been herded into a wilderness of sidings on the edge of the docks and, as if adding a final touch of ironic irreverence, within sight and sound of a singularly indifferent leisure complex on nearby Barry Island. The only mourners were railway enthusiasts making regular pilgrimages of sorrow to this last resting-place, and salt breezes that moaned corrosively around the skeletal remains. Here was a shanty town of stilled steam, with terraces of trains, cab to cab, boiler to

boiler, sinking in a sea of weeds—rusting, rotting, trapped and hopeless with no promise of tomorrow.

It was a moving spectacle—a morgue of locomotives. Like people, some had been celebrities in their day while others had played the part of the common man. There were Castles, whose kingdom ranged from Paddington to Penzance and which had once pulled expresses with thoroughbred ease to sparkling seaside resorts of palm trees and sandy shores; West Countries, with evocative names like *Tamar Valley* and *Tintagel*, used to steaming to the surf waves of the Atlantic Coast; and anonymous tank engines last seen coughing through the coal dust of Welsh industrial valleys.

With two years to go before the overall end of steam on British Railways, railway enthusiasts had not yet fully grasped the finality that Barry represented. When the last locomotives were withdrawn in August 1968, this South Wales scrapyard took on the historic importance of an archaeological find. For here was the very last round-up of British steam locomotives.

When Don visited the scrap-yard it was without the consoling knowledge that many more than could ever be imagined of these abandoned engines would one day be rescued by dedicated groups of preservationists. It seemed too much to hope even that they could be kept just as they were, let alone be restored to pristine condition and full working order. Yet as the preservationists became more determined to save as many examples as possible of our railway heritage, so their capacity to undertake seemingly impossible restoration projects grew. With skilled manpower and voluntary effort, the impossible was achieved. Engines were brought back from the grave. Once-famous classes were being saved from extinction, to be admired once more as masterpieces of locomotion.

Don decided to preserve the shapely lines of the engines through his paintings. It seemed highly unlikely that any would escape the cutter's torch and he resolved to restore them to their former grace on canvas. He was at the time having a final fling with abstract ideas and also exhibiting with the Industrial Artists Group at the London Guildhall. His railway paintings came as a shock to some London galleries. One proprietor, noting gleefully that in some of Don's latter works the engines were

steaming discreetly into the middle distance, proffered the hope that they would 'disappear altogether'. Fortunately they never did. Don felt that landscapes were a setting for something to happen in, like a stage waiting for an actor. For him trains offered a theatrical presence that vibrated with atmosphere.

Despite the added satisfaction he was getting from train paintings, Don was growing more and more restless. Meg had given up her teaching post at the college to have their first son, Ian. It was 1971, and Don and Meg faced a watershed period. They had reached a stage in their lives when they wanted to metaphorically 'shuffle the cards' and see if there was something different. For Don the challenge had finally dropped out of teaching. Although he enjoyed working with pupils, he found the schools were getting bigger, which resulted in

Cohens Yard
Kettering

more administrative work and less teaching. He was still doing his own work in his spare time but he found that much of his creative energy was being fed into the children. As a result his satisfaction came 'second-hand', in that he was taking pleasure in their work, with little energy left over for his own.

While the wind of change blew freshly through the Breckon household, Don gathered together a folder of his work and approached a number of graphic art agencies in London and Bristol. But after several chats about this style of commercial art the flirtation with the agencies ended. Don realised this was not for him. It was not art as he thought of it and so there was a happy return to the world of steam engines.

The lead-up to the final break came one day as Don stood in the kitchen looking out the window at the family motor caravan. He turned to Meg and said, 'I'd like us to get into that van and go.' Although he was subconsciously expecting Meg to say no, she surprised him by promptly agreeing.

So the idea became a tangible proposition. Everything was carefully considered and soon the house was sold and the motor caravan left Reading for the last time, towing a trailer-tent to provide extra space. Understandably, the reaction of family and school colleagues was less than favourable. How could anyone think of giving up their job, selling their home and embarking on a nomadic existence with no security? Everyone was horrified. Don and Meg could not see their venture in such 'tremendous risk' terms as others suggested. After all, they were both qualified teachers and at that time there was no shortage of posts in schools throughout the country.

Once on the road the Breckons forgot the freshly acquired tag of 'irresponsible' and started enjoying their new itinerant life style. Their tent was erected at various sites and was eventually pitched as far north as Cape Wrath. They visited friends, saw as much of Britain as they could and made the most of a touring sabbatical which was to last for seven months. Looking back, it was the first step, never to be regretted, into a new life. The 'gypsy existence' is always recalled with extreme pleasure. 'It was marvellous. We moved about with complete freedom. There were no bills piling up behind the door . . . It was like a breath of fresh air clearing our heads', he remembers.

Without a householder's day-to-day worries and chores, their perception of what they wanted grew clearer. They looked at the places they wanted to see and made the most of their mobility. But it was now the end of September and the campsites were emptying. They were at Bristol and decided to travel to Cornwall. Lostwithiel was reasonably central and so they made this the headquarters from which they would explore the county. As winter fast approached Don and Meg decided to rent a cottage in the town. After a brief return to Bristol they arrived back in Cornwall in November to take up their winter let. And Don started to paint.

Between the November and the following April, when they had to vacate the cottage for the annual influx of tourists, the Breckons looked at fifty houses as far apart as Penzance, Barnstaple and Newton Abbot. Unfortunately, while some of these potential homes were pleasant enough, the prices were less agreeable. It was now April and the search intensified as their time at the cottage ticked away. Yet it was an exciting period for, although problems inevitably occurred, something always seemed to crop up to solve them.

It was the day Don failed to find a blue biro to write a letter home to Corby that the Breckons suddenly became householders again. Meg had gone into the centre of Lostwithiel to buy a paper

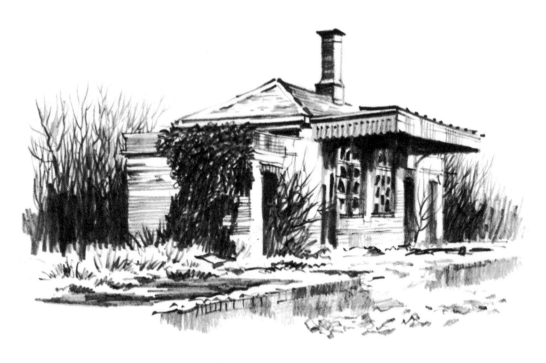

John o' Gaunt Station Leics

and Don, excusing the fact he could only find a red biro, began his letter: 'This is a red-letter day.' At that instant Meg dashed in, having scoured the paper for houses for sale and found a property that sounded ideal. It was a small end-of-terrace house in Lostwithiel. They liked it, could afford it and clinched the purchase at the estate agent's immediately. Afterwards Don concluded his 'red letter' with the information that they now owned a house.

He was at this time selling a painting a week, for £20 each, to a gallery to stay solvent. His fingers were always crossed for 'instant' sales, but providing nothing was rejected they were able to meet their commitments. Over the years his prices have escalated dramatically but it is interesting to reflect that before galloping inflation his original weekly income allowed a limited yet workable budget. He initially painted to school hours, out of habit, but gradually discovered that he preferred to start at 10.30am and work until 5pm, very often putting in several extra hours in the evening.

At the bottom of the cottage garden was a breeze-block shed which Don quickly converted into his first studio. He embellished it by fitting a homemade perspex skylight which leaked regularly in the Cornish climate, causing frequent puddles on the floor. He now worked seven days a week every week, the only debilitating side-effect being that he no longer knew which day of the week it was.

From the very first, Don was decided against the average West Country repertoire of harbours and fishing boats—he had seen too many painters shivering uneasily on the quayside while putting the finishing touches to some ultramarine seascape. Instead, his growing reputation was based on what appeared on the surface to be an unlikely commercial alternative, trains. But his paintings were not just about locomotives; they conveyed a nostalgia which people were attracted to immediately. Trains were in everyone's past and people wanted to possess a permanent image of something they remembered with affection. The demand for his work increased. Commissions came flooding in and the garden-shed studio became a 'steam workshop'. Engine after engine—from his Corby childhood and right up to the 'rare breeds' he found floundering in Barry scrap-yard—was reborn on canvas.

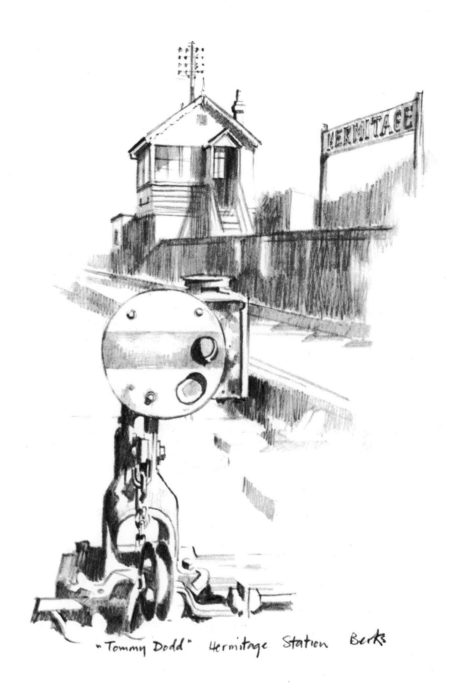

"Tommy Dodd" Hermitage Station Berks

Sketch for 'Somerset Local' 1978

between the rigid disciplines of locomotive design and the undulating curves of the surrounding countryside; the precision of steel against the amorphous swirls of steam. His trainscapes not only impressed enthusiasts but caught the imagination of people who could not tell one class of locomotive from another. And here lay his special artistic alchemy—an ability to conjure on canvas not only the 'rivet-counter's' accuracy, but also a nostalgia for a way of life long gone. People who once cursed the volcanic smuts of the steam age now remembered with affection childhood holidays that began behind a roaring Vesuvius which hauled them swift as a racehorse to the bucket-and-spade sunshine of some seaside resort. Images that had distilled into sepia recollections were reborn and revitalised on the Breckon canvasses.

He was now selling many of his paintings through Plymouth's Barbican Gallery, having approached Bill Hodges to see whether he was interested in hanging the occasional railway painting amidst his collection of land- and seascapes. It was a purchase made here by a lady associated with the BBC that led to the first 'Breckon' documentary being shown on television. Don's reservations about the media and a fear that all railway enthusiasts were inevitably branded lovable idiots or eccentric fools made his initial response to the idea less than favourable. But after the cameras invaded the garden shed his fears relaxed and he found the whole experience quite enjoyable.

Ideas for his paintings arrive through observation and imagination. Criticism, which Don willingly invites, comes from a wide range of commentators, such as the family butcher who would call once a week for a cup of tea and pronounce each painting 'average'. When he asked him to expand his opinions Don frequently found that they were extremely relevant and often altered some aspect of a canvas on his advice!

While creating a new painting Don will surround himself with as many reference photographs as possible. He scavenges picture magazines for subjects of interest and often visits the library. From originally being interested in the precision of the engine he has found that he has gradually become fascinated by the surrounding scenery. He

For the first time in his career Don was doing what he wanted and enjoying every busy minute of his seven-day week. He was also doing some part-time art teaching at the St Austell College of Further Education. To his surprise it was suggested that he should apply for a full-time job at the college—an offer, he recalls, that he would have jumped at when he was teaching at Reading. Much to everyone's surprise he turned down the chance of the St Austell post in favour of his railway

painting. He knew that if he became a full-time tutor once more his aspirations of becoming a successful artist would never be realised. And he would always be left wondering how far he would have got if he had devoted himself to painting.

He had made the right decision. A distinct Breckon style was emerging. His landscapes developed a classical Constable calmness, while his trains provided a perfect counterpoint of bustle and energy. The paintings explored the contrast

will use just the right type of period cottage to add authenticity to the setting, in time and place, which he is giving his train. Clothes and other details of our past offer extra clues to the period portrayed.

Against a background of Radio Four, with his ears particularly tuned in to listen to the afternoon play, Don begins working out his compositions. The basic lines are worked out first of all on a sketch-pad. Then the canvas is divided into thirds horizontally and vertically to form a grid, and the lines of the original sketch are enlarged onto this. The locomotive is drawn in meticulously as the dimensions must be accurate when painting begins. Then comes the 'blocking-in' process—covering the white canvas with the basic oil-paint tones to be used in the picture. The real battle now commences as colours are added, textures adjusted and everything pulled into harmony. The illusion of three dimensions materialises as the horizon is 'pushed back' and the foreground 'pulled forward' by the tricks of colour and perspective. The final highlights are then touched in. The engines have acquired their metallic sheen and the countryside its rustic quietude. The struggle beneath the competent brush strokes is glossed over in an end-result that communicates an aura of effortless skill.

A preference for the Great Western does not preclude frequent forays into the locomotive stocks of other regions and railway companies for new material. His subjects roam the main lines and branch lines of the railway network, both pre- and post-nationalisation.

As an artist Don is a romantic where trains are concerned. His engines are polished and well kept, with no hint of the grimy fate they were to suffer in their last years. His stations are freshly swept, with manicured herbaceous borders to cheer the traveller. The images so clearly evoke reality that the observer feels he can wander into the canvas and explore the surroundings. Porters and signalmen play their bit parts in the composition, and often there is a train-spotter watching from the lineside, a detail which harks back to Don's own younger days when he watched the trains go by. Now it is Breckon trains that go by.

Red Devon fields roll away as a 'chocolate-and-cream' express thunders down the Great Western main line with a Brunswick-green Castle in full cry. Here is the train in its natural environment—

Sketch for 'Earl of St Germans' at Sunset

sometimes intimidated by vast landscapes, and at others itself intimidating as it rattles over trembling bridges or bursts from single-bore tunnels in a halo of steam. On other occasions the balance weighs equal. The train, with its plume of steam and snaking coaches, becomes a perfect extension of the scenery. What we see is an overriding harmony between the railway and the rural tranquillity of its route.

The paintings are full of activity, played off against a backcloth of unchanging scenery. Trains come and go, but long after the express has stormed the next bank, the August oaks provide pools of cool shadows under listless boughs. The sun continues its westward curve across the sky and the trackside dozes until the ground is shaken awake by another approaching express . . .

It was 1977 and the Breckon family—increased by two more sons, David and Christopher—had moved to a delightful rambling cottage up the hill. Once again Don found himself before the cameras for a television documentary. This time the film

crew visited his new indoor studio, which had happily replaced the garden shed. After filming the artist at work here, the camera crew took him to the Torbay Railway for a footplate ride on GWR locomotive *Lydham Manor*. They then went back into Cornwall for some shots around Brownqueen Tunnel. (This was a setting Don was working on for a painting that was eventually to become a successful fine art print.)

But unfortunately for Don the whole enjoyment took a sudden nosedive when they hired a plane to circle St Germans viaduct, a site he was using for a special commission. The spectacular aerial views dulled considerably as the plane pirouetted on its side to swoop in on a passing train, so that the cameraman could snatch an unusual shot. Don lost all interest in his brief to 'say interesting things' and felt considerably 'indisposed'. The aeronautics of the Plymouth-based pilot dashed all his romantic illusions of flying a Spitfire over the white cliffs of Dover in one stomach-turning swoop. By coincidence, the completed documentary was broadcast

on the same night as his first one-man exhibition opened at Plymouth's Barbican Gallery. That evening Don went to bed happy in the knowledge that the exhibition was already a virtual sell-out, and that the television appearance had given his artistic activities an air of respectability in the community!

His canvasses have some of the immediacy of a camera—arresting the action for our eyes to linger, distilling the moment, freezing it forever. Yet paradoxically the imagination, once convinced of a subject's total authenticity, can take over where the artist has left off. The mighty locomotives that snort and charge towards the observer will, if the concentration is intense enough, roar right past. The noise will crescendo in an angry exhaust-bark with a cumulus of smoke. A name, number, smoke-box, cab, tender and a blur of coaches hurtle by, making the ground tremble beneath.

Trains travel through his paintings on important journeys or branch-line rambles. The smoke erupts fast and thick as they pass through the seasons—the gilded robes of autumn or the hushed whiteness of winter, when their breath hangs frosted in the crisp air. Some are reminiscent of hazy summers, childhood and holidays; of sunshine, school-days and visiting distant relatives. It is not just nostalgia for the train but also for the way we were.

The railways had a character and individuality that told you at a glance which part of the country you were in. A journey to the West Country meant not just the rich red cliffs of Torbay or the rhododendron-lined route to the Penzance peninsula but a Cornish Riviera headboard on a Castle with a glinting copper chimney and brass-edged splashers. The long haul north to Scotland would be all the more memorable for the traveller for being behind one of the maroon locomotives of the Midland or an impressive Gresley pacific from the LNER stable.

Breckon trains emerge from misty mornings, slip between the light and shade of deep cuttings, and sometimes run before the black clouds of a brooding storm as they attack the long drag of the famous West Coast climb over Shap. They skirt estuaries and sandy bays, sniffing the sea air and drowning the happy shrieks and squeals of the bathers with their own hot-breathed chatter.

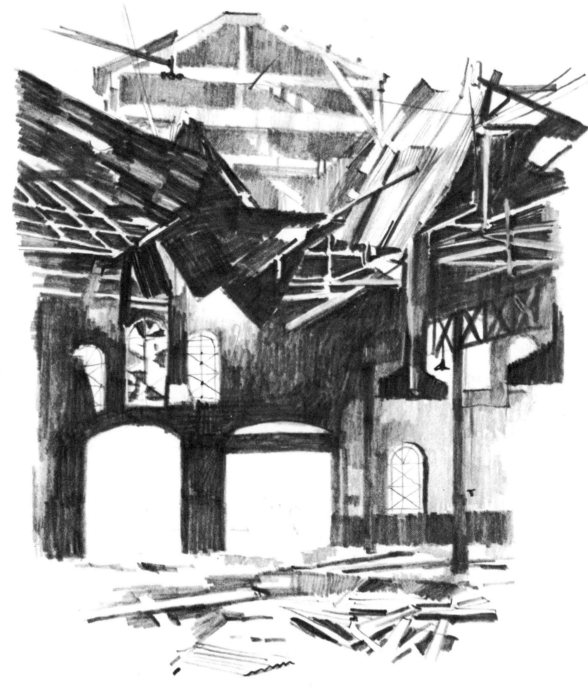

Demolition of Barrow Road Shed, Bristol

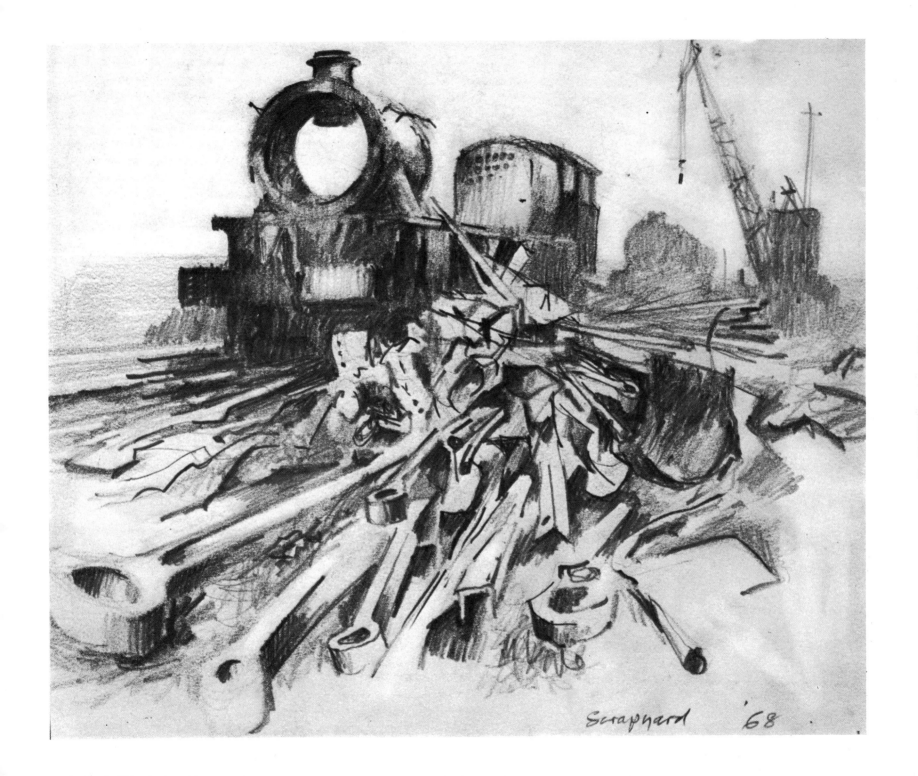

Scrapyard '68

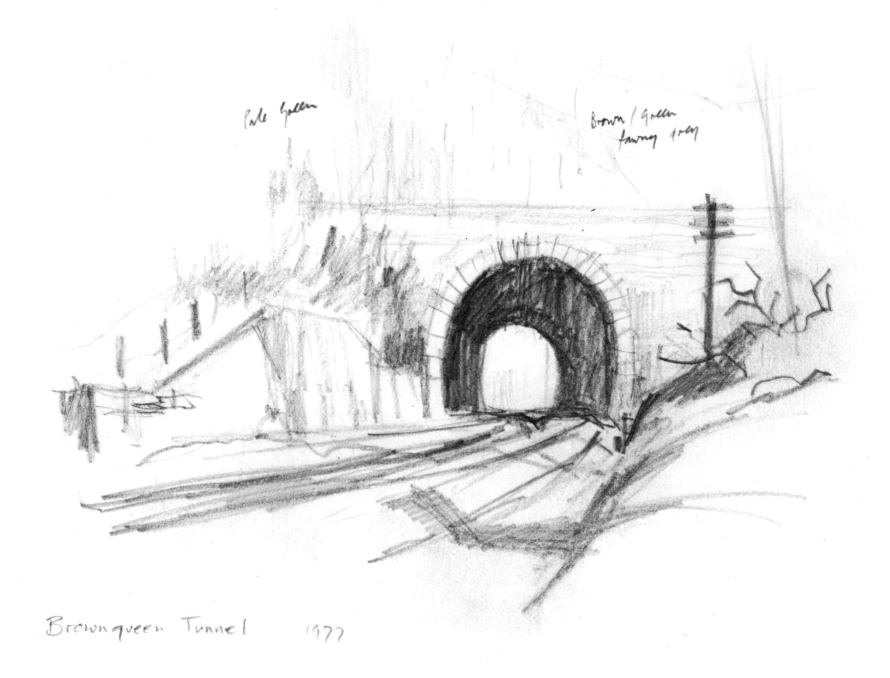

Pale Green

Brown / Green
tawny grey

Brownqueen Tunnel 1977

Board a Breckon train from beneath the gothic arches of a terminal station and the staccato beat of its exhaust will quickly blast you past the tenements, warehouses and factories of the red-bricked suburbs. Spires of cathedral towns glide by; slow sparkling rivers slide under bridges as the ribbon of rail weaves through lush landscapes unravaged by change. Here the train is a welcome intrusion and solitary figures look up to watch the passing spectacle. Clocks in lonely hill farms are checked against the distant whistle—which, if it sounds near tea-time, may be a daily reminder to set the cups and put the kettle on.

Rabbits scatter and rooks rise in a rebellious flock of black-beaked caws. Calves sprint from the trackside while their elders watch the passing iron horse with moony-eyed indifference. In valleys mint-green ferns unclench their fists, and drifting steam mingles with the scent of wild garlic. Primrose banks smudged pink with campions slip by. A buzzard circles high, catching the last warmth of the sun. Below, the steady beat of exhaust carries for miles on the evening breeze. A patchwork of fields retreats into the blue distance as the driver and fireman breast the last gradient before the homeward run. The first few lights twinkle in the approaching town. Signals show the road is clear. The crew ease their charge across the intricate station track-work, to stop the train in a hissing cloud of steam.

Don's particular evocation of steam was proving so popular that Bill Hodges of the Barbican Gallery approached fine art publishers Solomon & Whitehead to see if they would be interested in producing one of Don's paintings. They agreed and 'Sunday Working' came out in 1977. Within the year it was voted into the 'Top Ten' prints by a poll organised by the Fine Art Trade Guild. Don was delighted. Not only had he reached national recognition as a painter but had done so with a train as the subject. Another two 'Top Ten' successes followed. In 1978 there was 'Racing the Train' and the next year, when he enjoyed his first Bournemouth exhibition, came 'Manor at Brownqueen'. He had now moved into limited editions with a painting of Birmingham tram 'Number 33'.

As an occasional alternative to steam engines,

Don enjoys painting trams and, despite his own unhappy experiences of flying, aircraft from World War II. But he is primarily a railway artist and, furthermore, he is not just content to show the public side of a locomotive's life. He takes the observer behind the scenes to the 'domestic quarters' where the locomotives are coaled and watered, to the engine shed where men in oily overalls prime and preen their engines. This pride in the appearance of their trains was an attitude instilled when the old railway companies were locked in commercial combat. When the railways were nationalised in 1948, drivers and firemen still saw themselves as Midland or Great Western men and inter-regional rivalry persisted. Some sheds had won the reputation for turning out immaculate

locomotives to work prestigious expresses and for many years they endeavoured to retain this distinction.

From the smallest shed right up to the largest an atmosphere pervaded which rushed to the head like a rich wine—the pleasant odour of hot oily steam leaking from valves as the engines rested between duties, the sudden sound like cold water poured on boiling fat as they 'blew off' excess pressure. A shed was a locomotive lair where the congenial dragons snorted and rested in their slumber. Outside there was a steady cavalcade of arrivals and departures at the coaling tower, with tenders being topped up for the next trip, and inside was an Aladdin's Cave of surprises. Stepping in from the brightness the eye quickly discerned the sleeping shapes: a coven of classes disappearing into the distance; driving-wheels taller than a man; grease-coated coupling rods; puddles of oily water; diffused sun filtering through the cathedral-roofed gloom, weaving threads of ochre light across the engines; and always the sound of escaping steam. Here was a smoky Elysium where the smell and sights inside the shed elated the enthusiast's senses as opium would the addict's.

Looking at Don Breckon's train paintings it is hard to believe that the subjects no longer exist outside his canvasses. Many preserved engines are now running on restored lines, but the living, breathing atmosphere of working steam is gone for ever. In each one of his nostalgic paintings Don reminds us of what we are missing in a world that has dismissed character and individuality in favour of streamlined efficiency. There is extra speed and there are smoother rides, but the atmosphere has gone and with it an intrinsic part of the pleasure of travelling by train. A lot of people share the same sentiments as the painter, and it is this delightful craving for railway nostalgia, coupled with his own creative talent, which has made Don Breckon the success he is today.

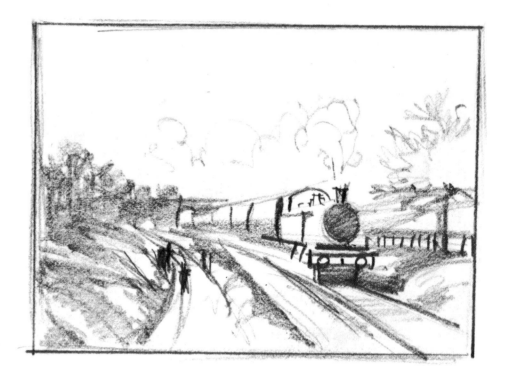

Layout roughs

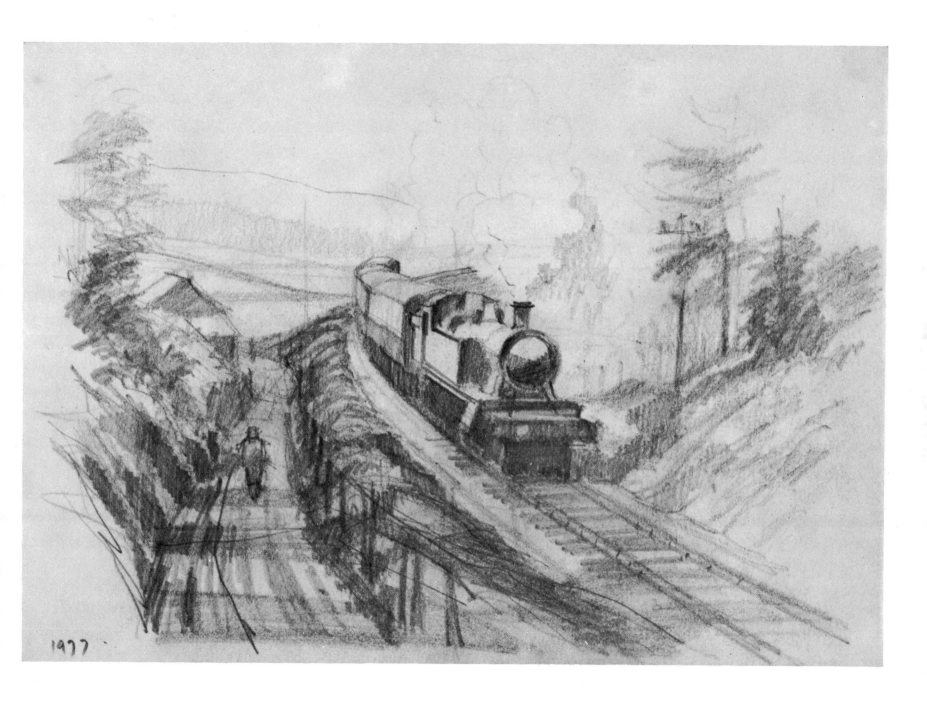

1977

THE PAINTINGS

MANOR AT BROWNQUEEN (1977)

In 1977 BBC South West decided to do a programme in the 'Peninsula' series on my work. Producer Kevin Crooks asked me to choose a location near Lostwithiel for my next painting, so that they could film there.

I had 'discovered' Brownqueen Tunnel some time earlier and had been impressed by the north portal, with its retaining wall alongside the track, and surrounding woodland. As part of the programme involved my first footplate trip on *Lydham Manor* on the Torbay Railway it seemed appropriate to include a Manor in the painting. This presented a problem, however, as Manors do not seem to have been residents of Cornwall in GW days, but 7814 was based at Bristol in 1947 and could well have wandered down the line.

The shadows and old sleepers gave horizontals to balance the verticals of the trees, and the fireman leaning back to catch the shout of the lineside worker gives added impetus to the train rushing past.

After being used as the basis for the television programme, the painting went on to the Barbican Gallery and later became my third Solomon & Whitehead print, reaching the 'Top Ten' list of the Fine Art Trade Guild. I was right to be impressed with the north portal of Brownqueen Tunnel!

Great Western 4–6–0 Manor class locomotive, No 7814 Fringford Manor, *heads a stopping passenger train out of Brownqueen Tunnel between Lostwithiel and Bodmin Road. No 7814 was at this period (c1947) based at Bristol (Bath Road) shed. Built in 1939 (one of the pre-war batch of twenty) it was finally withdrawn from service in 1965.*
32 × 24in

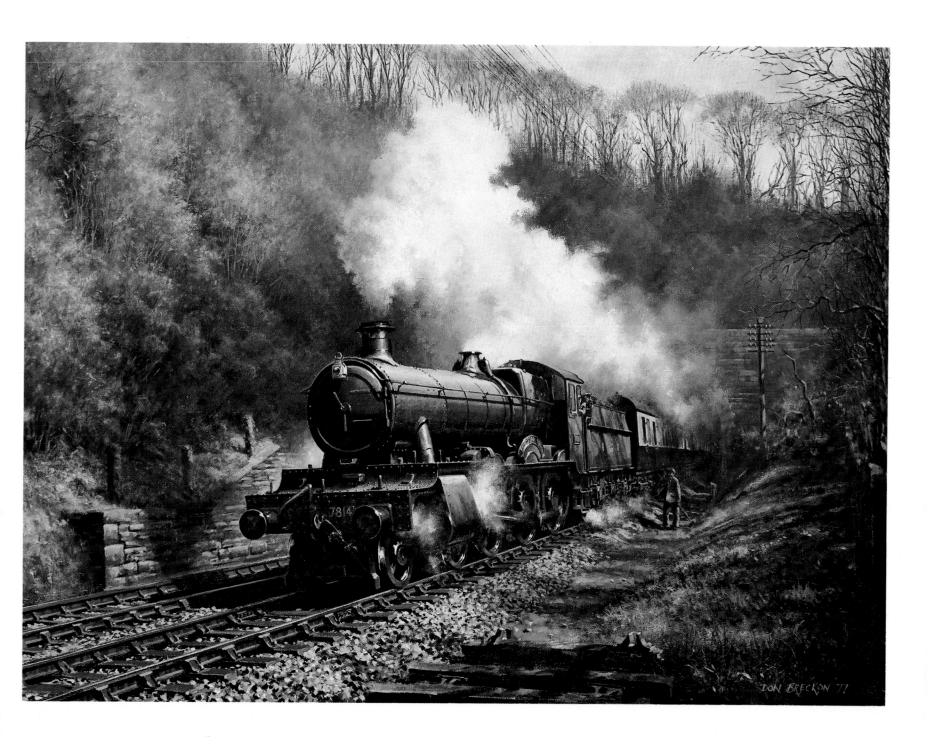

EVENING STAR ON SHED (1975)

This is two paintings in one. It was a sunset scene with *Evening Star* heading an express in 1974, but I reworked it the following year and replaced the sunset by the interior of a locomotive shed. Despite the changes, the basic idea of light on the side of the engine and the front in deep shadow remains. The dim light suits the bulk of *Evening Star* and it looks better than it did at sunset!

I have vivid recollections of visiting Barrow Road shed in Bristol a few days before closure when 9Fs were being moved around with 'end of term' casualness by young lads in dungarees. The dripping gloom inside the shed was genuine enough, though, and it was a sad sight when on my next, and last, visit the shed was deserted, with large sections of the roof caved in.

The name *Evening Star* was chosen as appropriate for the last steam locomotive to be built by British Railways, especially as it was built at Swindon and the name was one from the old Great Western Star class. Names can certainly give an identity and a feeling of character to a locomotive—even today's diesels. Names have been gathered from many sources to adorn railway engines, from military regiments to birds and from racehorses to characters from fiction. Once embarked on a theme for naming their main-line engines, however, some railway companies must have wondered about the results! When the LNER chose racehorses as a theme for their Gresley pacifics they did get *Royal Lancer* and *Robert the Devil*, but they were also landed with *Pretty Polly* and *Salmon Trout* which are not readily associated with a powerful steam locomotive!

On the other hand when the North British took the names of Sir Walter Scott's fictional characters for their Scott class 4–4–0s they found some lyrical sounds for an engine, particularly when it is trundling along a branch line, such as *Wandering Willie* or *Jingling Geordie*.

Generally, however, I feel that a locomotive name must have an element of drama (*Thunderer*, *Wolf of Badenoch*, *Royal Scot* or *Spitfire*) or dignity (*Duchess of Atholl*, *King George V* or *Isambard Kingdom Brunel*) to do justice to a main-line steam locomotive. Better sometimes no name at all than something at odds with the machine which carries it.

British Railways Standard class 9F 2–10–0, No 92220 Evening Star, *moves 'on shed'.* Evening Star *was the last steam locomotive built for British Railways—it was built in 1960 and withdrawn five years later. It is now in the National Railway Museum in York.*
30 × 20in

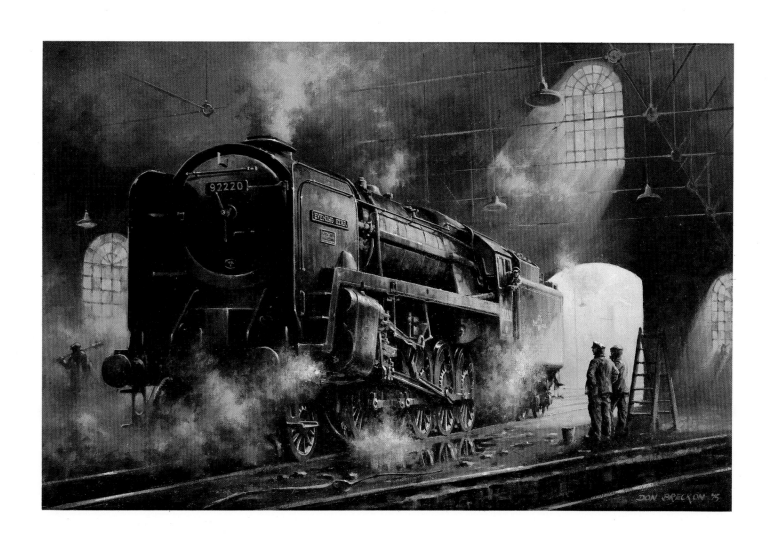

A STAR IN WINTER (1974)

A Star in a pre-1936 (red headlamps) snowy landscape. The central position of the train in this wide canvas gives possibilities for opening up the picture space but creates problems of balance. An embankment on the far side of the track would have been limiting so, although based on Hatton Bank, I dropped the ground there so as to push back the distance on the left-hand side.

The footprints of the lineman in the snow give notice of his progress before the train arrived, and extend the feeling of a period of time rather than an instant 'snap-shot' moment. Anything which develops the feeling of time before the train arrived, and even the time after it has gone, helps to build the impression of the permanence of the scene contrasting with the fleeting appearance of the train.

I am surprised at how crucial to the painting is the barn in the left middle-distance. It is such a small shape and yet without it the painting would be much changed. Planning is important but it is often the lucky 'accidents' which make all the difference.

Great Western 4–6–0 Star class locomotive, No 4021 British Monarch, *heads a north-bound express through a wintry landscape in the early 1930s. No 4021 was built in 1909 and named* King Edward. *In 1927, with the introduction of the King class, No 4021 was renamed. Locomotive headlamps on the GWR changed from red to white in 1936.*
40 × 16in

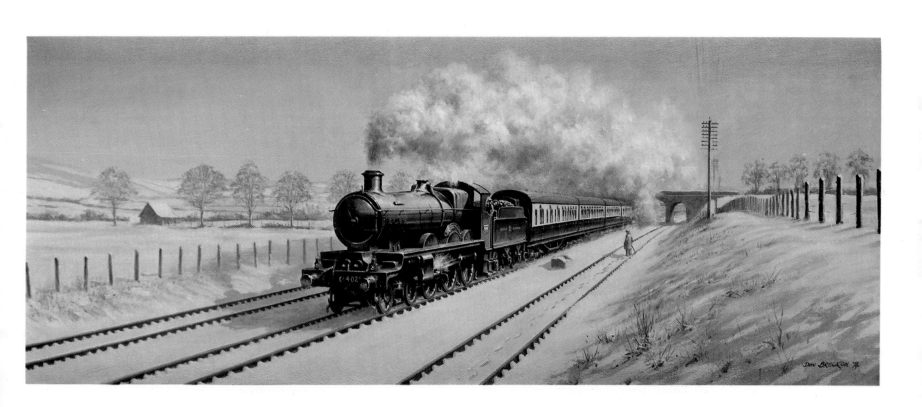

TRACTION (1977)

An earlier painting of a tractor and a train had worked out well and I was interested in the theme for a larger work. The relationship between tractor and plough grinding slowly across a furrowed field and a train moving on smooth tracks of steel creates an interesting comparison.

I gathered details of tractor and plough from a tractor rally near Stamford, culled the clump of trees from beside the road to Fowey and laid out the composition. The sea-gulls were important not only for authenticity but to create a swirling, swooping pattern in the space between tractor and train.

With camera and sketch-book I went down to Mevagissey, where, on a previous visit, I had seen more sea-gulls than I had believed possible in one town. I arrived at the quayside and not one! After a trip to the local baker I scattered some bread rolls on the quay and waited. They came from nowhere like a host of dive-bombers, the bread rolls were gone in a flash and so were the sea-gulls, leaving me with blurred photographs and an empty sketch-book! I retired to the local library (sea-gulls section).

I am sometimes asked how long it takes to produce a painting. It can take between one and four weeks, depending on the subject and how the work 'flows'. There are usually one or two days' research needed before I can begin. This is always interesting, but can be frustrating if I am itching to get on with it! I used to work a seven-day week, but now I prefer to take the weekends off unless the painting has reached a stage where it is 'rolling' and the momentum needs to be sustained.

Actual painting begins about 11am each day and goes on until tea-time, with sometimes a late night run until around 10pm. In the early years I worked occasionally until 1am, but I have since given up such youthful pursuits!

A Fordson 'F' tractor of 1936 and a Ransomes plough are hard at work as a Great Western express passes, its engine surging up the gradient with the heavy train. The engine is a 4–6–0 Castle class, No 5078 Beaufort, *built at Swindon in 1939 and withdrawn from service in 1963 after running 1,038,165 miles.*
36 × 24in

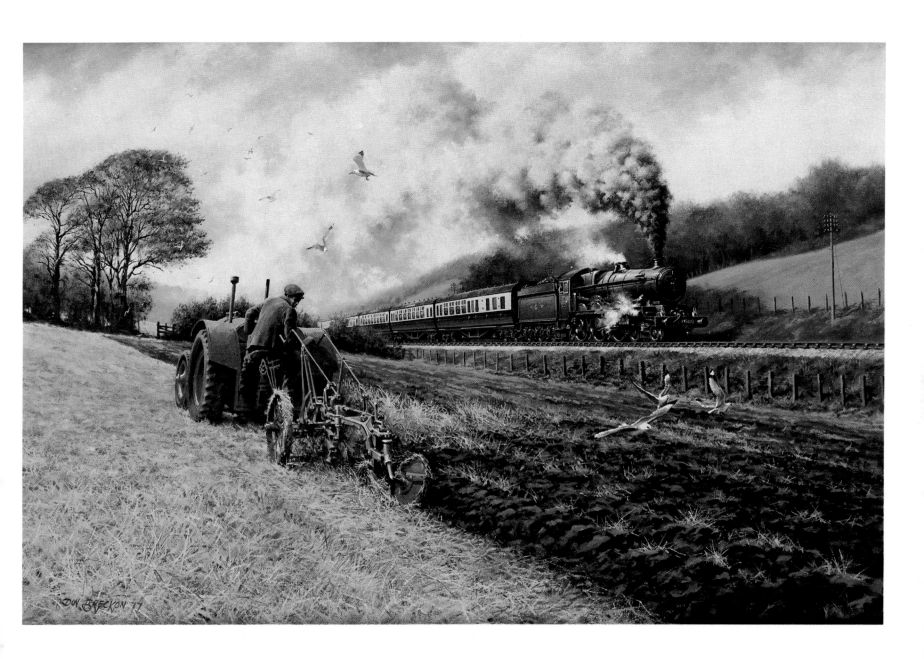

THE RIFLE BRIGADE (1979)

The windswept moorland of Shap Fell has a drama of its own, but it is heightened by the sight of a steam locomotive battling with weather and gradient. The rebuilt Scot with its purposeful front end seemed appropriate for this setting, and I used the swirling smoke and the shadows of passing clouds on the distant fells to give the impression of a stiff breeze.

My memories of Shap belong to the last few months of steam working when my brother, Ross, and I drove up in my Mini estate car from Reading. We had a magnificent weekend around Shap (despite the weather) and an unforgettable wet evening at Tebay station with steam-hauled trains coming and going as though diesels had never been invented.

My brother's enthusiasm was to prove more lasting than mine, however. We slept in the car near Scout Green and every time he heard the sound of a steam locomotive he leapt out into the night! At 2am I put sleep before trains! Still, I do have a few photos from that weekend and there's always those fine Peter Handford recordings of Shap in the great days.

Ex London, Midland & Scottish 4–6–0 Royal Scot class, No 46146 The Rifle Brigade, *on the slopes of Shap Fell with an express for Glasgow. No 46146 was built in 1927, rebuilt in 1943 and withdrawn in 1962 after running 1,400,036 miles.*
24 × 18in

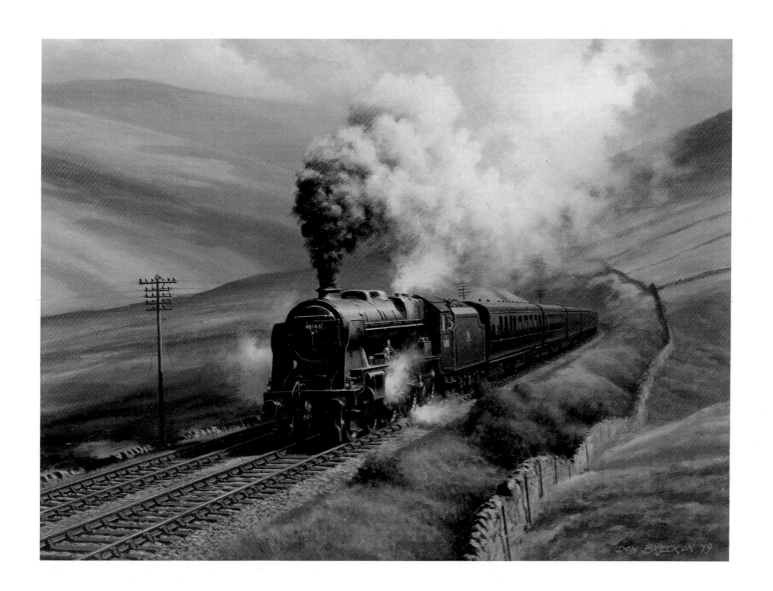

Don Breckon 79

NORTH BRITISH (1977)

This was a commission from railway photographer Patrick Russell and was worked directly from one of his photographs as he requested.

The locomotive was No 256 *Glen Douglas* which was restored to its original livery and used on special trains until 1965. Taking the opportunity for a little 'poetic licence' I changed the engine number to 307 (*Glen Nevis*) and introduced period coaches to take the scene back to the early 1920s.

Working from photographs is necessary for an artist concerned with technical accuracy, but they are only the tools of the trade, like brushes and paint. When I am painting, photographs, sketches, books and magazines, all relating to the work in hand, are strewn around the room, and it is the cumulative effect of all this information, plus imagination, which shapes what happens on the canvas.

Of course a visit to the location, where possible, is a tremendous benefit. Working on a painting of a mixed train crossing Dartmoor I had laid out the train, with smoke and thundery sky, but was not doing well with the grass and rock-strewn landscape. I loaded paints and canvas into the van and drove up to the moor near Princetown. Sitting painting in the van (it was very windy), I was aware of a local lady peering in the window, obviously perplexed by the steam train in the picture. 'You never saw *that* today!' she cried. 'Ah, it's just wishful thinking,' I said. She laughed and went happily on her way.'

North British Glen class 4–4–0, No 307 Glen Nevis *(later LNER class D34), climbs Dalgetty Bank, Fifeshire. The leading coach is a through coach from the Great Northern. From a photograph by Patrick Russell.*
24 × 18in

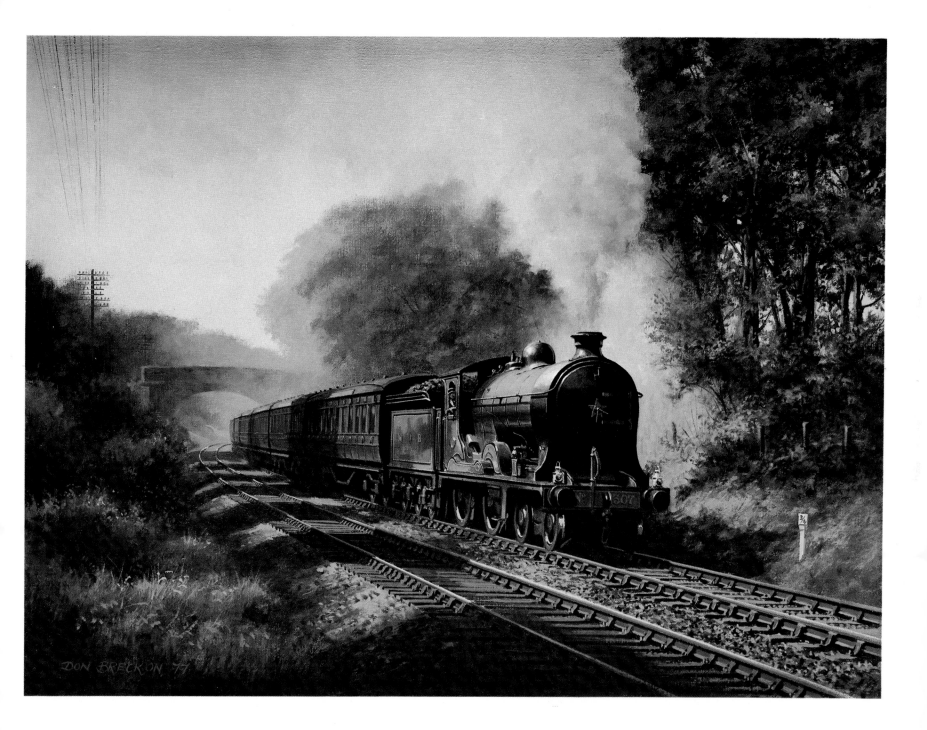

WORKING AT THE SHED (1979)

It is usually only the railway enthusiast who finds anything exciting about an engine shed. To most wives of those enthusiasts paintings of sheds are 'dirty pictures' and do nothing for the décor of the lounge!

The atmosphere of the steam shed was magical to those who loved locomotives, however, and the relationship of man and machine was seen as nowhere else on the railway system. Looking at a shed painting a friend said that he was surprised to see that steam locomotives were so big—he had only known them at station-platform height.

In this scene the cleaners are at work on a Hall, giving me a reason for placing figures over and round the engine, creating a surround of activity on a static engine—a reverse of the usual situation. The shed buildings are loosely based on Swansea (Landore), though I have moved things about to balance the composition.

The nearest I got to an engine shed when young was peering into the gloom at Kettering shed from a window which faced onto the station forecourt. When I took up teaching, however, and ran the school Locomotive Club, I found that engine sheds were the places which the boys most wanted to visit (probably because it was difficult for them to get in by themselves).

In their company I visited Crewe, Camden and Swindon and I was glad of the experience. I could hardly savour the atmosphere to the full, though, with fifteen boys dispersing in all directions to write down the number of everything they could find! I tracked some of them down in the scrap lines at Swindon jotting down the numbers on a pile of smoke-box doors!

There was a wonderful aroma and atmosphere in the dark depths of a steam shed and if some enterprising fellow had bottled some of it he might have a ready market for it today! Even though we have much to be thankful for in today's preservation movement, the 'glorious grime' of scenes like this remains locked in the past. Visiting the excellent York Railway Museum I had the thought that perhaps a corner could be roped off and 'de-restored' back to its original grime, with a work-stained engine standing in the dripping gloom which the enthusiast remembers but the general public have never seen.

Engine cleaners at work on GWR Hall class locomotive, No 5913 Rushton Hall, *while Castle class, No 5016* Montgomery Castle, *is being made ready for the 'road'.* Rushton Hall *was built in 1931 and* Montgomery Castle *in 1932; both were withdrawn in 1962 (5016 running a total of 1,480,896 miles). The location is based on Landore, South Wales.*
30 × 20in

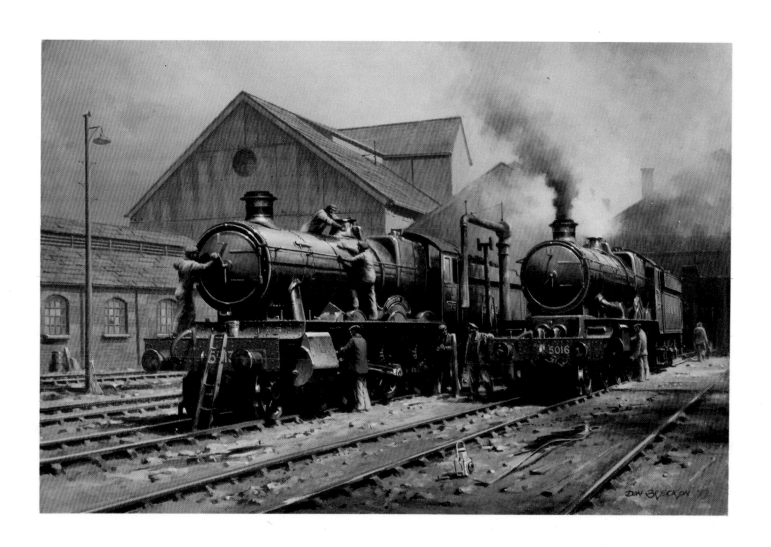

JINTY AT THE CROSSING (1979)

This painting was a commission from Mr D. Wheeleker for an LMS engine with three girls at a level crossing. I collected some photographic references at the Severn Valley Railway, on which I saw this engine gleaming in the sun at Bridgnorth. I decided that it would look well on a branch-line train.

Just as I had often used the green of the GWR in a summer landscape, it seemed that autumnal browns would go well with the LMS black. I wanted the girls to be an animated group—this animation could be explained by the fact that they knew the engine driver rather than by an overwhelming excitement over trains! The setting is an imaginary one, but I hope typical of an LMS branch line. The verticals—the trees on the right, the telegraph pole, lamp and locomotive chimney—counterbalance the horizontals and shallow diagonals of the train. The block shape of the signal-box does the same for the small figures of the children around the crossing.

I am sometimes asked with paintings such as this, 'Where is it?', and when I explain that it is not an actual place I wonder whether the reply is a disappointment. However, when I asked one chap about this he said, 'Oh no, because now I can make it wherever I like.' Anything which leaves scope for the imagination cannot be wrong I suppose.

This painting was chosen to be my fourth print with Solomon & Whitehead, and was the first not to feature a Great Western locomotive.

London, Midland & Scottish class 3F 0–6–0T, No 16466, has an appreciative audience of three local girls as it heads a branch-line train over a country level crossing. 16466 was built in 1926 (one of a numerous class nicknamed 'Jinties'), then renumbered 47383 by British Railways and withdrawn in 1967. It has been preserved and is now active on the Severn Valley Railway.
30 × 20in

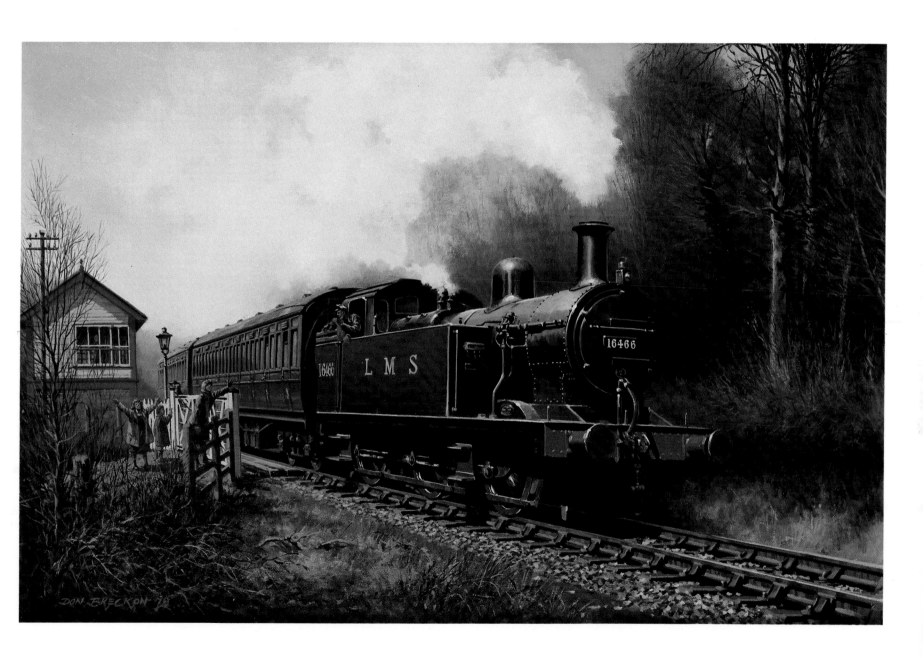

BACK FROM TOWN (1981)

Over a cup of coffee David St John Thomas talked about his concept of the typical country branch-line station scene. The engine shunting a wagon from the train, the people taking the footpath home, the station forecourt with the hotel taxi etc. David's interest was mainly with the people and the activity surrounding the station; the landscape and the locomotive were of interest to me.

After a few rough sketches I reached the compromise of running the footpath parallel with the railway—the people *and* the engine shunting could then have a prominent position in the painting. The station forecourt would have to be pushed back but its size would mean that the area would still convey the activity there.

I began work on a larger rough sketch of the layout for David to see. Dividing the picture space into three, vertically and horizontally, gave me a good proportion division for the main shapes and focal points. I took a viewpoint to one side of the footpath on a rising slope with a tree to the right casting a shadow across the foreground 'linking' right to left. By running the footpath into a dip in the ground the main figures did not obscure the station area and the fencing posts could be lowered so as not to get too involved with the wheels of the engine!

I was rather bothered about the shunting of the cattle truck because, despite the shunter with the pole, it did seem as though part of the train had broken away accidentally.

David was happy with the rough layout and came up with a further suggestion about the shunting—a bracket signal with the siding arm. As he tells in his *Country Railway*, David enjoyed pulling such a signal as a boy at South Molton when a cattle truck of cattle was detached from the evening passenger train. Here it is lowered to show that the engine was not off down the main line!

Now it was time to pick up a 30×20in canvas and get to work on the painting. As it progressed, however, there was still some research work to do. The station building was based on Avonwick, the goods shed on Fairford and the engine on five or six good photos of a 45XX 2–6–2T. I looked through old family photographs for details of old ladies' hats and coats of the late 1940s and a photograph of an old Dennis bus taken at Crich Tramway Museum was just right for my village transport.

One of the good things about painting in oils is the chance to make alterations as the work progresses. The old lady, like the boy, was looking at the engine until I reckoned that she'd be too tired after a day's shopping to be looking around her! Then the small pond beside the footpath 'grew' into a stream so that I could insert the little plank bridge and add interest to the flow of the footpath.

When the painting was finished I looked back at the early sketches and felt that it had worked out reasonably well. I'm still not too sure about that shunting, though!

Great Western class 45XX 2–6–2T, No 4526, shunts a cattle truck during a halt at a West Country station. The hotel taxi and village bus are in the station forecourt, but a group of passengers laden with their purchases from town prefer the footpath across the fields.
30 × 20in

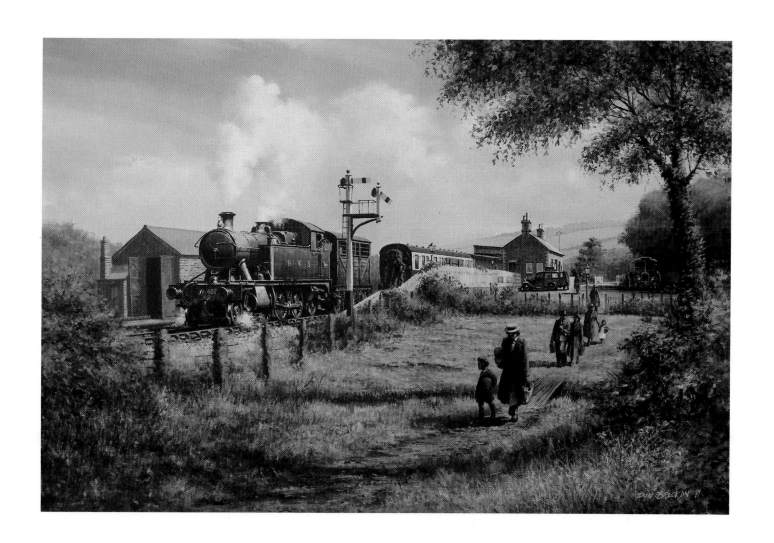

ALONG THE TAMAR (1976)

Driving over the Tamar road bridge I had often looked down on the old Southern line running along the shoreline towards Bere Alston and thought how fine it must have looked when a Bulleid pacific was heading an express along those tracks.

A photograph in an old magazine of a T9 with the Saltash railway bridge in the background gave me sufficient reference to get going on a painting. I kept the GW influence with a freight crossing the bridge. This also gives a sense of scale to the structure, while the two boys 'trespassing' on the embankment give life to the left-hand side and, with the GW engine in the distance, help to balance the composition.

The Southern Railway and the Great Western performed some interesting acrobatics with one another in the far west and it must have seemed to passengers that it was deliberately perverse for them to be going in different directions whenever they met (at Plymouth North Road and Exeter St Davids).

A comparison between the journeys of the Great Western's Cornish Riviera Express and the Southern's Atlantic Coast Express through Devon and Cornwall shows the different situations of the two companies. The Cornish Riviera Express headed purposefully for Penzance, every ounce a prestige train which must not be hindered in its progress. The Atlantic Coast Express, however, became something of a passenger version of a 'pick up goods' in Devon and Cornwall, where it dropped off coaches for as many as eight different destinations before it finally arrived at Padstow. This is not to deny, however, that the Atlantic Coast Express had a character all of its own, and when I visit the remains of Padstow station and look up at the Metropole Hotel up on the hill it is not hard to imagine the scene in earlier years, with passengers from Waterloo spilling onto the platform and porters loading luggage into the dogcart to be taken up to the hotel. Of such things is nostalgia made.

Bulleid Battle of Britain class pacific locomotive, No 34051 Winston Churchill, *heads the 'Brighton' express away from Plymouth. An east-bound freight crosses Brunel's bridge over the Tamar on the Western Region main line. No 34051 was named at a ceremony at Waterloo station in 1947 and is now preserved.*
30 × 20in

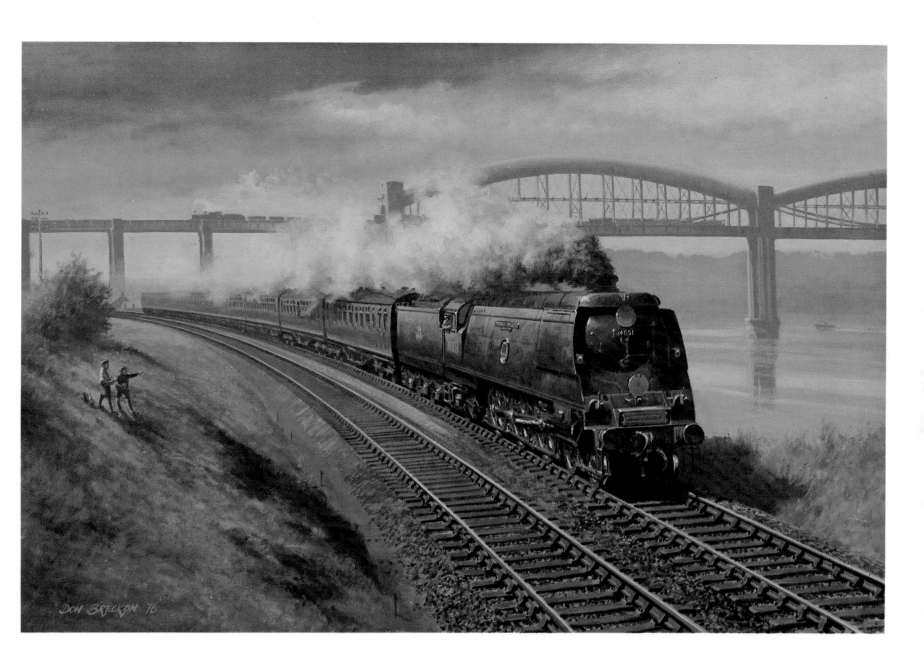

EARL OF MOUNT EDGCUMBE (1978)

It is often the small things in a painting which give the atmosphere, and it was a detail of this one which started the whole scene.

Driving back from, I think, Exeter, at sunset I saw someone open the door of a small farmhouse and stand silhouetted against the warm glow inside. The light in the house, a little world in the gloom, contrasted with the huge fiery sunset across the sky. Add an evening express lit by that sky, I thought, and that would be quite a picture!

The introduction of puddles in the ruts of the farm track brought some of the sunset sky into the bottom of the painting, but it was the addition of the workman plodding home to his cottage which suddenly gave meaning to the figure waiting in the doorway and the atmosphere of the end of the day.

I had already gathered several photographs of sunsets over Lostwithiel by clambering onto the roof of my first garden-shed 'studio'. (Though more often than not the effect that made me rush for my camera was gone by the time I got up there!)

Great Western 4–6–0 Castle class locomotive, No 5043 Earl of Mount Edgcumbe, *heads an up express at sunset.*

No 5043 was built at Swindon in 1936 as Barbury Castle *but the name was changed when it became one of the twenty-one 'Earls' of the Castle class. In 1956 a double chimney was fitted, and withdrawal took place in 1964 (after 1,400,817 miles). After many years in a South Wales scrap-yard, No 5043 is now at Tysley, Birmingham.*

40 × 16in

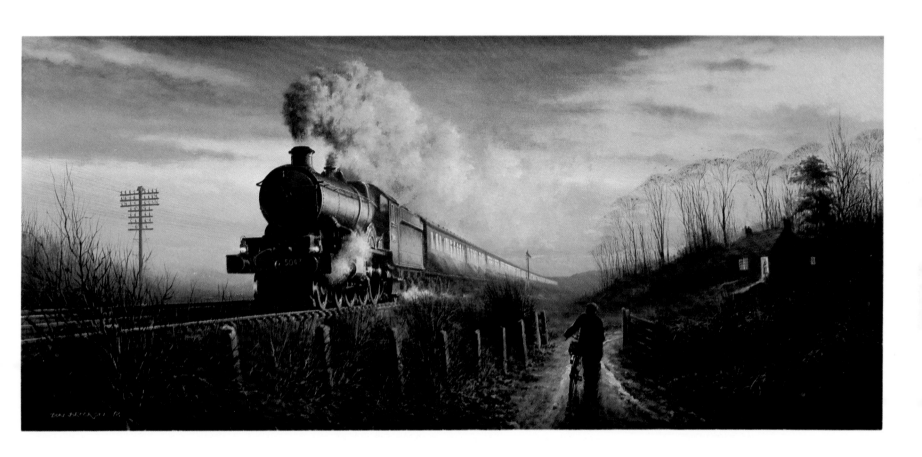

NIGHT STOP (1977)

I remember when I was young being amazed that trains could rush through an inky black night with only a few twinkling dots of signal lights in the distance to warn the driver of what lay ahead.

The fascination of trains at night remains and I have always experienced something of that feeling from my youth at the sight of the engine of a night express just clear of the platform-end, with its long boiler barrel pointing into the darkness beyond the station lights. The footplate too, with its fiery glow, eerie shadows and the scrape of shovel on coal, becomes a different world at night.

I tried to work all these aspects into this painting, the figure on the right not only balancing the composition but his huddled form and the cold light from his lamp contrasting with the dominant form of the driver of the King.

I have an affection for this painting because it reminds me of a very special day for me—1 July 1977. It was the day that my first real 'one-man show' was to open at the Barbican Gallery in Plymouth, and on the same evening BBC TV (South West) were showing a film on my work. Such events brought my parents and brothers and sisters-in-law down from Bristol. In the morning they all went off to Plymouth while I stayed at home gardening. (I hate openings of exhibitions—especially if they are mine!) I was in the yard chatting to the builder, there to fix our chimney, as he was eating his lunch. Suddenly everyone was back with the news that the exhibition had almost sold out in the first hour! The builder stoically munched his sandwiches through the ensuing scenes of jubilation!

We had a pleasant afternoon in the sunshine. The Wimbledon Ladies' Final was on TV and my wife, Meg, was almost as pleased about Virginia Wade's win as she had been about the exhibition! In the evening we all watched the 'Journeys into Light' programme which crowned the day nicely.

'Night Stop' was, I think, the last painting in the exhibition to sell and it was bought early the following day.

Great Western King class 4–6–0, No 6015 King Richard III, *at the head of a night express, awaiting the 'right away' from a main-line station.* King Richard III *was built in 1928 and withdrawn from service in 1962 after running 1,901,585 miles.*
36 × 24in

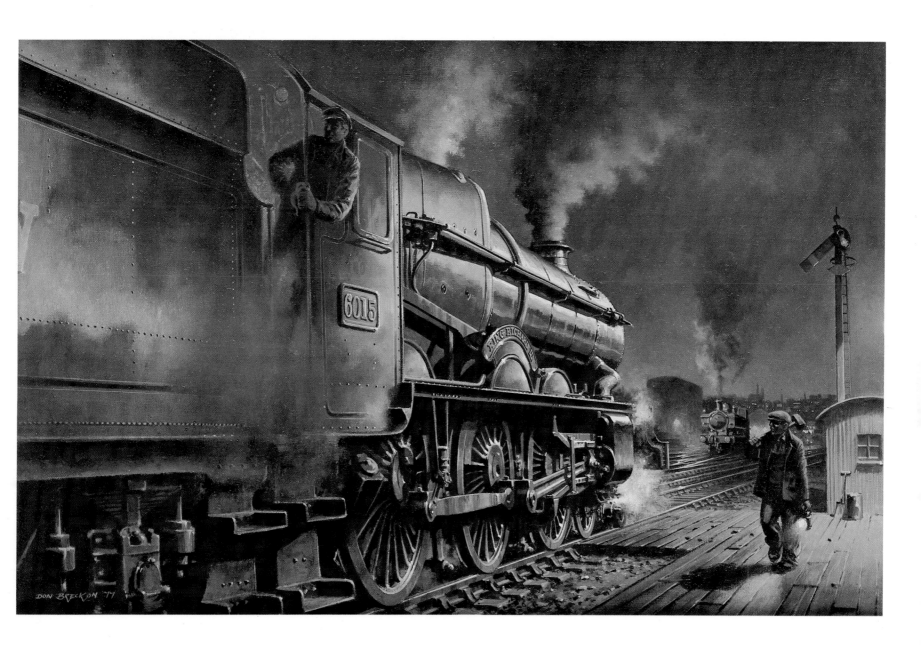

FOWEY VALLEY (1977)

Ian Kitt was impressed by this view during his work on a farm looking down on the River Fowey. When he commissioned a painting of the scene and took me to see it, I shared his enthusiasm. Only diesel-hauled clay trains used the branch, but it seemed ideal for placing the 'Fowey Rattler', as it was known locally, back in the setting.

A tributary joins the river here, winding in under the Milltown viaduct which carries the main line up the gradient to Treverrin Tunnel and St Austell. The Fowey branch diverges just outside Lostwithiel station about two miles off to the right. I had used the location on two previous occasions, looking from beneath the viaduct, but it was a real pleasure to do this 'bird's-eye view' of the scene.

A trip down the tidal River Fowey on the 'Rattler' was so pleasant that local people have told me that they would often take the train to Fowey and back just for the ride (shades of today's preserved lines).

The line had a varied career. Opened in 1869 as a broad-gauge branch from Lostwithiel, it closed ten years later. After the gauge conversion it reopened and, although closed to passengers in 1965, it is still active as a rail link with the clay wharves at Fowey. In recent years it has seen two unusual workings, however. On one occasion a bird watchers' special train crept down the branch to allow the passengers to view the river birds at low tide, and on another a chartered train provided a mobile grandstand for a boat race!

An amusing tale is told locally of the days of the steam auto-trains on the branch. A national serviceman was being given an unofficial footplate trip from Fowey on a 14XX tank loco-motive, propelling its coach back to Lostwithiel. The driver was in the coach and only the fireman was on the footplate with the young man. Realising that his passenger was not aware of the fact that the driver was controlling the train from the auto-coach, the fireman waited until his passenger was admiring the view and then swung himself out of the cab and up onto the coal bunker. The young man turned from the delights of the river to find himself alone on the footplate of the speeding locomotive! His thoughts before a cheery 'Yoohoo!' came from the fireman grinning down through the cab roof can only be imagined!

Great Western 14XX class tank engine and auto-coach (known locally as the 'Fowey Rattler') making for Fowey, down the valley from Lostwithiel. The Milltown viaduct beyond carries the main line from Plymouth to Penzance. The branch line along the Fowey valley was closed to passengers in 1965.

30 × 20in

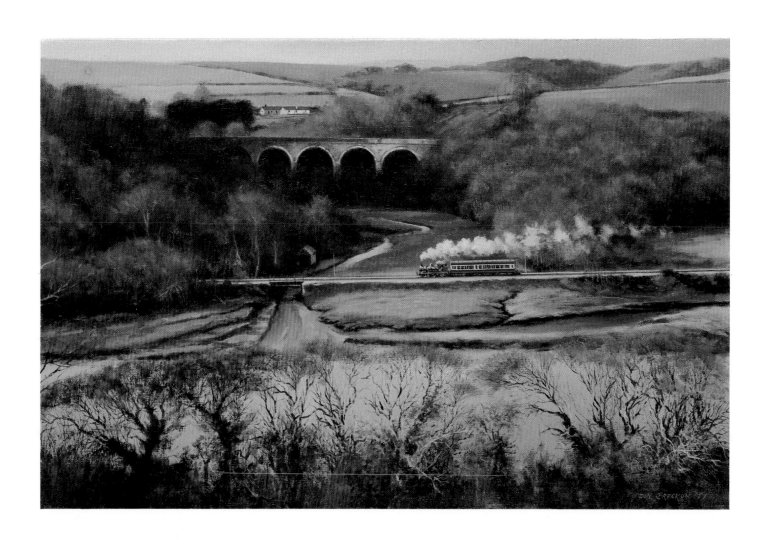

SUNDAY WORKING (1975)

The suggestion for a train with a group of lineside workers came from a Birmingham gallery, but I would have come to it eventually anyway, because it was a natural bringing together of men and locomotive. I had done many sketches of Victorian railway navvies from old photographs, having been impressed by the sense of strong character which came over from these faded prints. Using these sketches as a basis I assembled a group of updated tired, tough figures.

The locomotive choice was 6861 *Crynant Grange* because I had been determined to resurrect it in a painting ever since I saw it waiting, with two other Granges, for the cutting torch at Cohen's Scrapyard near Kettering.

The title 'Sunday Working' was chosen because track-work on main lines is often carried out on Sunday when traffic is light, and so the title applies to both the train and the men.

I was delighted when Solomon & Whitehead decided to use the painting for a print and even more so when it reached the Fine Art Trade Guild's list of top prints in 1977.

Unfortunately I have committed a couple of technical blunders in lining out the locomotive and fitting the later style of chimney. For those who notice such things I am truly repentant!

Original of the print published by Solomon & Whitehead (one of the 'Top Ten' prints listed by the Fine Art Trade Guild). Great Western 4–6–0 Grange class locomotive, No 6861 Crynant Grange, *heads a Sunday stopping train past a permanent way gang in the late 1940s.* Crynant Grange *ended its days at Cohens Ltd in Northamptonshire, where it was cut up for scrap. 30 × 20in*

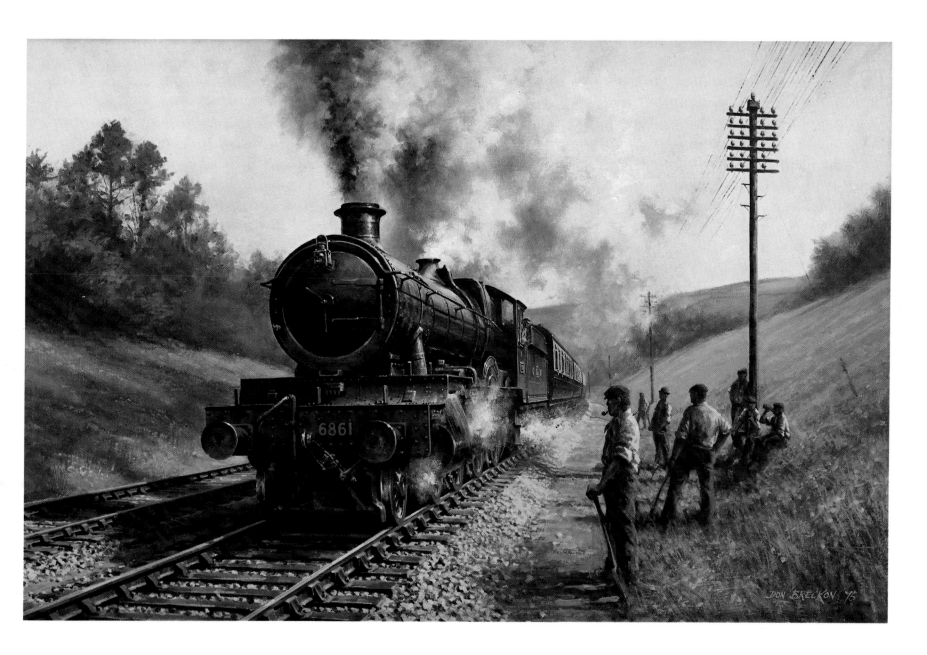

KING'S CROSS (1977)

The A4 pacifics have a lot of admirers among railway enthusiasts and of course the streamlining gave them a certain aura. North of the Thames they were the only streamlined engines to be seen since the LMS removed the casings from their Coronation pacifics. So the excited cry of 'A streak! A streak!' from hordes of small boy train-spotters meant the sighting of an A4.

I first saw them on their racing ground at Tallington, north of Peterborough. There we sat on the fence, bikes propped up beside us, sandwiches and 'pop' mingling with our 'combines' (combined volume of the engine names and numbers of all regions).

We were intrigued on one visit to Tallington by the activities of two cameramen who were intent on getting a shot of an A4 from between the tracks! Fortunately they had a remote control camera which they placed on the sleepers and after much rushing back and forward they departed with (hopefully) just what they wanted. I was reminded of this years later when I saw the excellent British Railways Board film *Elizabethan Express* which has some wonderful shots of *Silver Fox* on the non-stop run to Edinburgh.

Mallard heads the list of preserved A4s (as befits the world record breaker) and with several examples saved from the cutting torch the class has fared quite well in the preservation stakes. Unfortunately *Silver Fox* is not among the survivors.

It must be said that without the familiar boiler barrel they are not everyone's idea of a steam locomotive. One chap's wife looked at a painting of one which I was working on and said 'Oh, you're doing diesels now'!

Ex London & North Eastern Railway class A4 pacific, No 60017 Silver Fox, *pulls away from King's Cross with a north-bound express as class A1/1, No 60120* Kittywake, *backs down to the terminus.*

24 × 18in

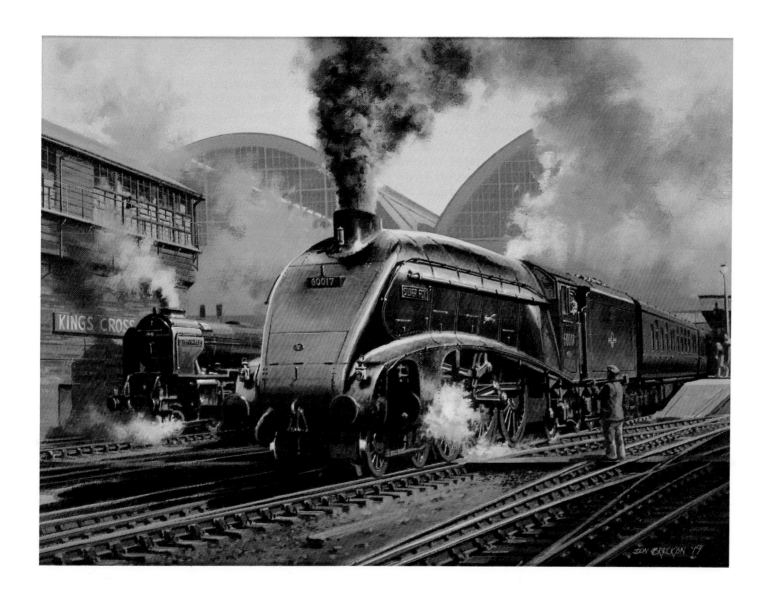

LOSTWITHIEL STATION (1981)

When we first came to Lostwithiel early in 1972 the station was still intact except for the foot-bridge which had recently been demolished. 'They said it was unsafe,' said a neighbour who worked on the railway, 'but it took us a hell of a time to get it down!' The station still looked a picture, with palm trees on the platform, and was used for 'location shots' for the BBC TV play 'Stocker's Copper'. Close inspection showed peeling paintwork, however, and rumours began to circulate about BR plans for demolition.

A preservation group was formed and after many meetings and interviews in the local press and on TV, a petition, and pleas to Sir John Betjeman and the Duke of Edinburgh, it seemed that they might win the day. British Railways moved with alacrity, however; on a Sunday morning in May 1976 the demolition gang started work at 6am on the down-line buildings which had served for the main-line and Fowey-branch platforms. I joined the disconsolate group at the station watching the destruction.

It seems that the following day Peter Shore, the then Secretary of State, asked British Railways to desist from the demolition work but they replied that it had gone too far.

The original wooden building of 1859 was saved and it stands today with large beams supporting the canopy. Plans are once again afoot for its demolition. In place of the old down-line buildings stands a squat little 'bus shelter' structure.

In view of the impending complete disappearance of Lostwithiel station, I felt that I would like to 'put it all together again' before the last reference points were gone.

The finished painting was on show at Ann's Gallery in Lostwithiel and it was very warming to hear the comments of affection which the local people still had for *their* station.

The down Royal Duchy Express runs through Lostwithiel station in Cornwall headed by ex Great Western 4–6–0 Castle class, No 5010 Restormel Castle. *In this late 1950s scene the platform for the Fowey branch train is to the right with empty clay wagons from Fowey docks in the siding beyond.*

40 × 24in

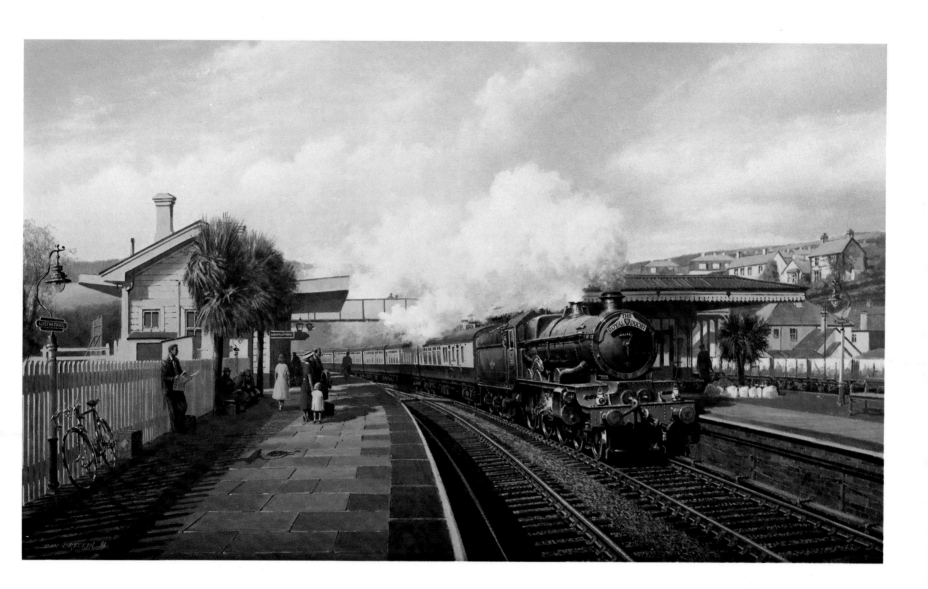

TUNNEL (1977)

Now and again an idea for a dramatic or unusual painting of the railway scene comes to mind and this was one such.

A visit to the short and curving Brownqueen Tunnel and an old photograph, taken below the road-bridge, of the ruined Nancegollan station amalgamated to form the idea. Only when I was half-way through working on the painting did I realise that I had a viewpoint which no photographer could have taken—unless he was prepared to risk life and limb for his craft!

Trains meeting on a gradient like this are always interesting because of the contrast between the locomotives, one drifting lazily while the other battles with the incline. The coming together of the three elements—earth (coal), fire and water—in a steam locomotive may explain something of its fascination. There is also the fact that it can be seen working—the connecting and piston rods moving like the rippling muscles of a shire horse. Indeed, the analogy does not end there because a locomotive slipping at the head of a heavy train, wheels spinning and smoke and sound bursting from it, is so much like a war-horse rearing up on its hind legs and snorting defiance.

All of which is of course rather romantic; it was the late L. T. C. Rolt who defined the appeal of railways as that which satisfied both the romantic and the classical sides of our nature:

> For the romantic the speed and power of the steam train epitomises the freedom and romance of travel, while the whole atmosphere of the railway is magic. Yet at the same time the classicist within us is aware that this romance is in fact the byproduct of order and discipline, that a great railway system is perhaps the most elaborate and delicate yet at the same time one of the most successful feats of organisation ever evolved by man.

Great Western 4–6–0 Castle class, No 5006 Tregenna Castle, *emerges into the sunlight as 4–6–0 Hall class, No 4920* Dumbleton Hall, *comes pounding up the gradient towards the tunnel.* Tregenna Castle *was built in 1927 and withdrawn from service in 1962. This locomotive held the world speed record in 1932 when heading the Cheltenham Flyer (average speed 81.68mph).* Dumbleton Hall *was built in 1929 and withdrawn in 1965. In 1976 it was rescued from a South Wales scrap-yard for restoration and preservation.*
36 × 24in

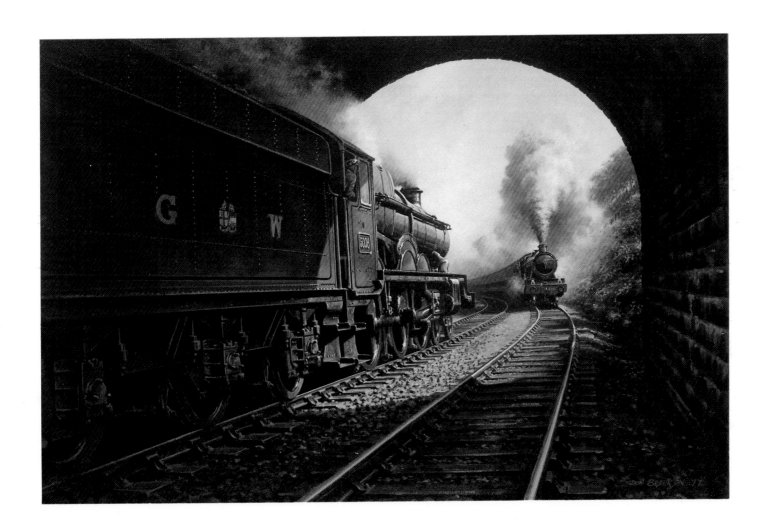

MOORSWATER SHED (1976)

I had seen photographs of this shed on the old Liskeard & Looe Railway. A trip to the site in 1975 showed that it was no more and I gathered all the reference material I could, in order to resurrect it in a painting.

The great appeal was that it was an engine shed apparently lost in the woods, almost tucked away under the main-line Moorswater viaduct which towers 150ft over it!

The original line of the Liskeard & Caradon Railway is to the right of the engine shed and was opened in 1844 to serve the quarries and mines of Caradon on Bodmin Moor. A strange aspect of this line was that, although it did not officially carry passengers, if someone sent their umbrella or a parcel by train they could obtain a 'free pass' to travel with it! Eventually the railway extended to Looe and, by a steep sweeping curve from Coombe Junction, up to Liskeard station.

The GWR took over the line in 1909, though near the shed the fire-box of the line's first locomotive survived—as a lavatory!

By the time of the painting the line to Caradon was closed and the 45XX prairie tanks were working the Liskeard–Looe branch. I have imagined it on a summer morning with two 45s being made ready for the day's work. The shed staff are busy but the chap leaning on the wall enjoying the sunshine is obviously 'awaiting instructions'!

The two-road engine shed at Moorswater, Cornwall on the Liskeard to Looe branch with class 45XX 2–6–2Ts, Nos 5502 and 4565, being prepared for the day's work. The shed was built by the independent Liskeard & Looe Railway in 1893 and closed in 1960.
36 × 24in

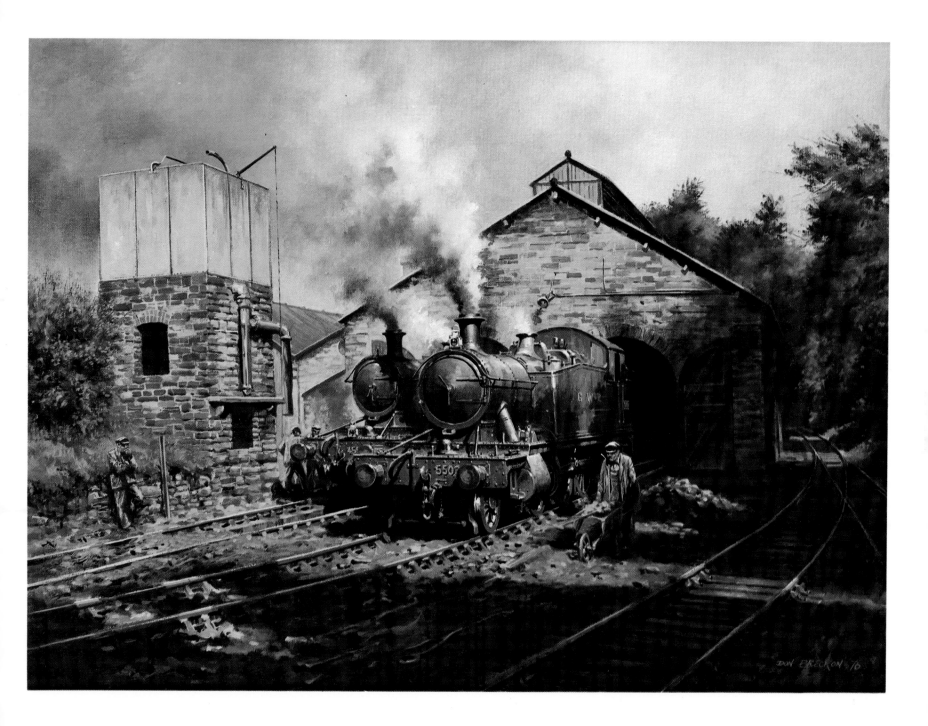

BRITISH INDIA LINE (1976)

I was commissioned to paint this locomotive, the location being left to me. I found the low-angle view of the rebuilt Merchant Navy gave a sense of power and speed to the locomotive, but it left me with a ditch for a foreground. A photograph of a flooded lineside ditch with overhanging trees brought the solution. I could have a dark L shape of foreground and trees, with the light on the water cutting through the darkness to bring sky colour down to the bottom of the painting.

The Merchant Navy class locomotives were built with streamlined casings and *British India Line* was the first to be rebuilt without the casing in 1956. With their distinctive Bulleid wheels they came through the transition very well and, in the final years of steam, hauled expresses on the West of England line where they attracted a large following of enthusiastic admirers.

On a visit to Basingstoke to have a look at these engines at work my brother, Ross, and I got carried away with the chance for one last trip. I had to ring up my wife and say: 'Put lunch in the oven—I'm afraid we're in Bournemouth!'

Rebuilt Merchant Navy class pacific, No 35018 British India Line, *heads a Southern Region express. No 35018 was the first of the class to have the original streamlined casing removed (in 1956).*
24 × 18in

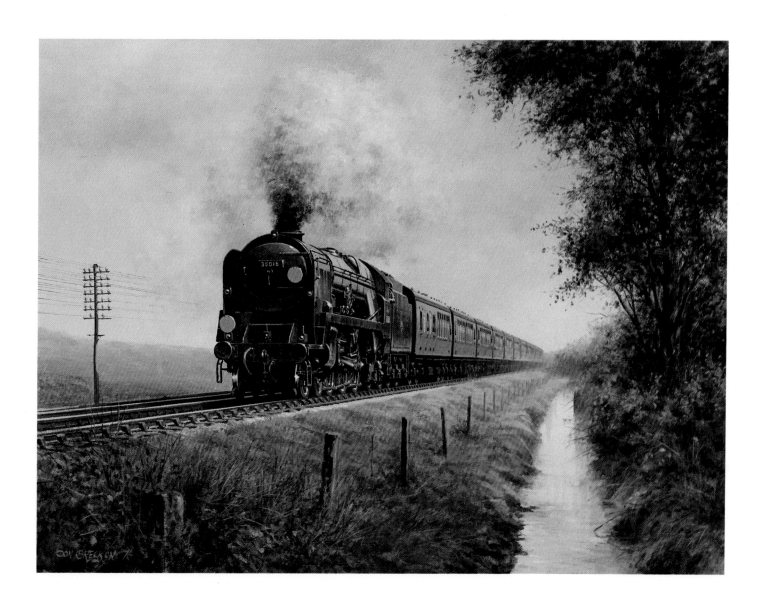

RACING THE TRAIN (1977)

There is a track running down alongside the main line at Respryn Bridge near Bodmin Road and this was the beginning of the idea for this painting. The main line became a branch line in order to give a good angle view of the 45XX and local train; the landscape grew around it to balance the composition. (The tree on the right grows just outside Bodmin—artists are visual scavengers gathering bits from here and there!)

The boys on the farm track were a late addition—I had intended to put an old man watching the train going by. Where the idea for the racing boys came from I do not know, though I think it was something I saw my own boys doing as part of one of their games. The reaction, however, from those who have seen the painting suggests that *everyone* 'raced the train' at some time or other during their youth!

In 1977 I was taking an evening class in St Austell and showed the painting to the group as a discussion point. After some time one woman said that she knew what was round the corner of the track behind the barn, and went on to describe the landscape out of the left-hand side of the picture! When we had all recovered we realised that she had used the painting as a starter for her imagination and that was not a bad thing at all. In fact when a painting has triggered off the imagination it is no longer simply layers of colour, tone and texture—the subject becomes a personal reality.

'Racing the Train' went on to become a 'Top Ten' print and one has reached the walls of the school in Reading where I taught until 1971. Perhaps the best result of all, though, is a press photograph which was sent to me of a retiring railwayman being presented with a 'Racing the Train' print by his union branch. He does look genuinely pleased!

A boy on a farm track tries a quick burst of speed in competition with a Great Western branch-line train. The train is headed by 2–6–2 prairie tank locomotive No 4570. Built in 1924, No 4570 spent its working life in the West Country before being withdrawn from service in 1963. 32 × 24in

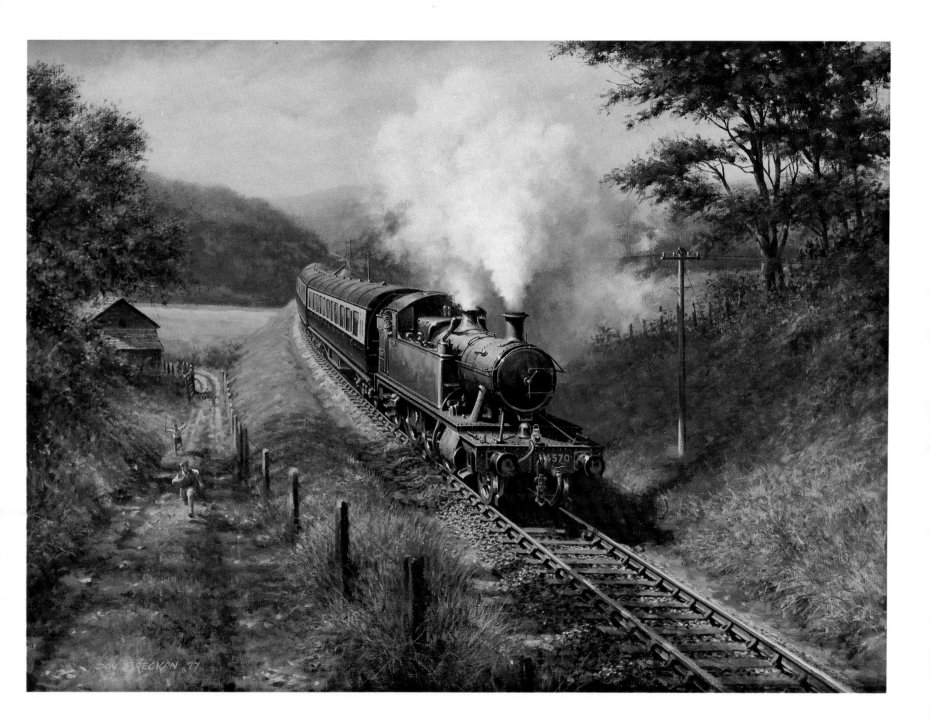

DON BRECKON '77

When the Barbican Gallery commissioned a set of four sepia gouaches, I felt that a theme of branch line trains at country halts from all four companies (GWR, LMS, LNER and SR) would suit the medium and scale of the limited edition prints which were to be produced.

WAYSIDE HALT

The GWR 14XX class locomotives had an Edwardian period charm despite their 1930s construction date. They are just right on a wandering West Country branch line, as the Dart Valley Railway proves to this day. The distinctive pagoda-roofed shelter on the wooden platform of the halt completes the 'Western' flavour.

A Great Western 14XX class 0–4–2 locomotive with a two-coach train pauses at a wayside halt to collect a few passengers for the short trip down the branch line.

MIDLAND LOCAL

The Johnson 1P 0–4–4s worked branch line trains for the Midland Railway, the London, Midlands and British Railways. Built in 1881 some were still in service in the 1950s.

The angular rear half of the locomotives contrasted strongly with the elegant curves of the front boiler area but they still had a purposeful air.

A London, Midland & Scottish Johnson class 1P tank locomotive, No 1340 (later British Railways No 58053) pulls away from a branch-line halt with a two-coach local train.

SOUTHERN CROSSING

For the third in the series of prints commissioned by the Barbican Gallery I chose the Wainwright H class 0–4–4 to represent the Southern Railway branch-line engine.

Thinking of the four prints as a set I had to consider balancing angles. The GWR and LMS had been upper views, left and right, so the SR and LNER would be lower views, right and left.

The lower angle view of a locomotive emphasises the power and size and so it proved with the H class—losing perhaps a little of the charm of the engine evident at other angles.

The H class 0–4–4s were built for the South Eastern & Chatham Railway between 1904 and 1915, some of the class working until the 1960s.

A Southern Railway Wainwright class H 0–4–4 tank locomotive pulls away from a country halt and over a level crossing with a two-coach local train.

EASTERN BRANCH

Completing the 'quartet of tanks' for the Barbican Gallery prints is the London and North Eastern C12 4–4–2T at the head of a couple of eastern clerestory coaches.

Although I cannot remember seeing one of these engines at work, I remember visiting the interesting Stamford East station which was one of their regular haunts.

Built at Doncaster in 1898–1907, the last of the C12s was not withdrawn until 1958.

A London & North Eastern Ivatt class C12 4–4–2T, No 4520, makes a lively start from a halt on an eastern branch line.

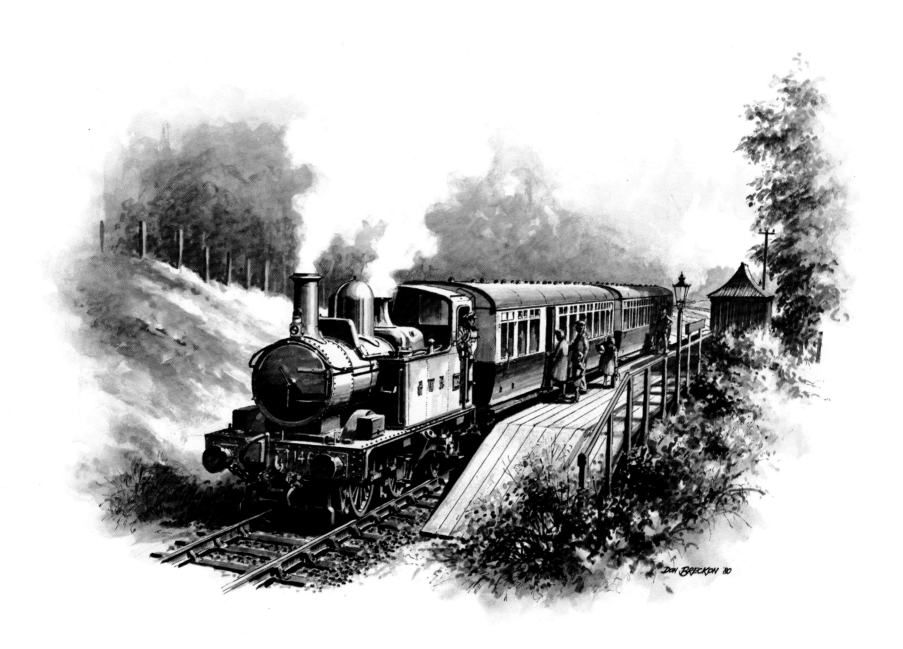

WAYSIDE HALT

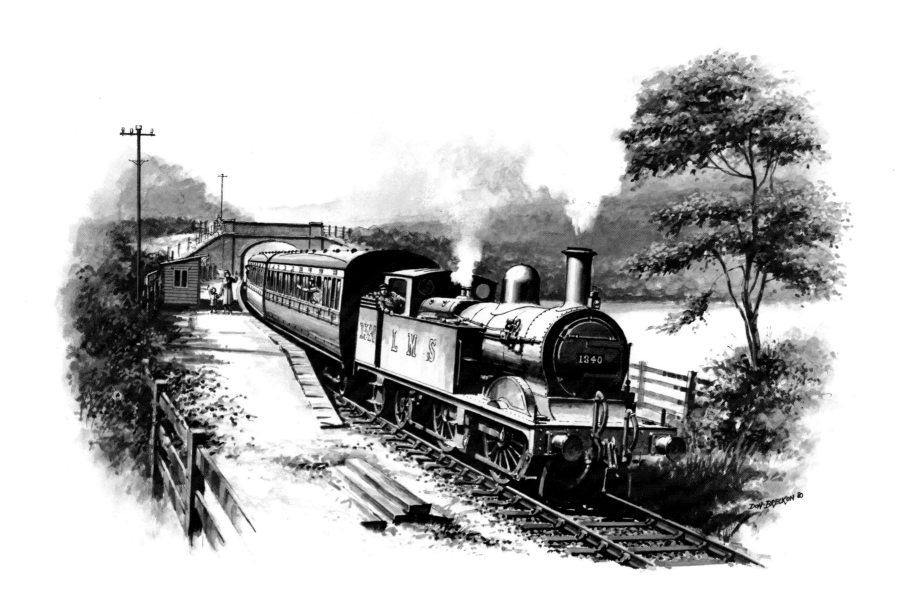

MIDLAND LOCAL

SOUTHERN CROSSING

EASTERN BRANCH